IMAGES
of America

GALT

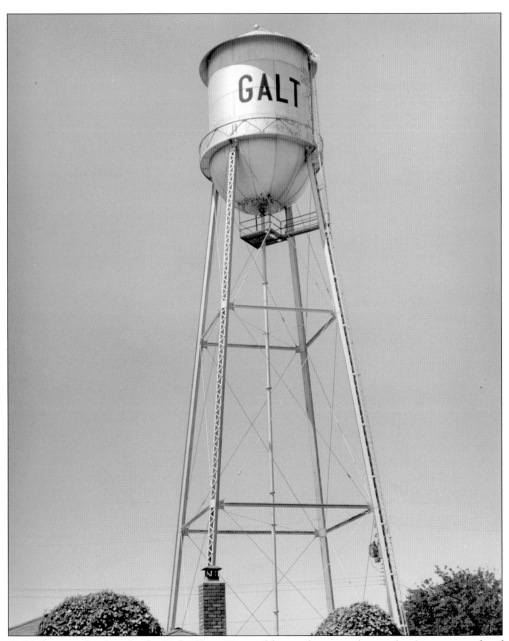

Galt's historic landmark, the Galt Water Tower (this is the second one, the first was made of wood), still stands as a beacon to those Galtonians returning home. It is said that during the Great San Francisco Earthquake and resulting fires of 1906, citizens stood on the original water tower to see the glow in the western sky.

ON THE COVER: A picnic of the local chapter of the Native Sons of the Golden West is nestled in one of the many groves of live oaks surrounding Galt. This could be the area nicknamed White Bridges northwest of town, a popular recreation area enjoyed by many Galtonians over the years.

IMAGES
of America

GALT

Daniel Tarnasky

ARCADIA
PUBLISHING

Published by Arcadia Publishing
Charleston, South Carolina

Printed in the United States of America

Library of Congress Control Number: 2016947566

For all general information, please contact Arcadia Publishing:
Telephone 843-853-2070
Fax 843-853-0044
E-mail sales@arcadiapublishing.com
For customer service and orders:
Toll-Free 1-888-313-2665

Visit us on the Internet at www.arcadiapublishing.com

*This book is dedicated to all the Galtonians both far and near
who remember the town we grew up in. It is hard to see progress
and not have memories of a simple life in a small town.*

CONTENTS

ACKNOWLEDGMENTS

Working on this book has been a labor of love that will never be forgotten. Most of the photographs and information came from the Galt Area Historical Society, which has spent most of the last 29 years accumulating historical photographs and documents to preserve for future generations. Those members who provided great assistance were Louise Loll Dowdell, Maria Cabral Spannuth, Judy Jacobson, Janis Barsetti Gray, and Genie Olson. Other Galtonians, both far and near, who stepped forward were Wilma Vandenburg Bianchi, Dennis McAllister, Sharon Spaans, Wanda Steiner, Linda Fletcher Burge, Bill and Carol Bland, Dody Hatchell Wasser, Jim Spaans, Chuck Nelson, Kathy Lanza Whirlow, and Bonnie Rodriguez at the *Galt Herald*. A special thanks to my title manager Liz Gurley, who put up with a lot.

Personal gratitude goes to my wife, Sonja, who endured many nights of me at the computer and meetings with prospective image donors. This project was not going to be a best seller, but it was a great deal of fun and something to be proud of, and she was behind me 100 percent.

Unless otherwise noted, all photographs are courtesy of the Galt Area Historical Society, of which I am a proud member.

INTRODUCTION

Long before the first settlers arrived in California, the Miwok Indians lived and hunted the great Central Valley. In the Galt area, it was the Plains Miwok whose tribes included the Cosomne, Sonolomne, and the Unizumne. Their philosophy was to live in harmony with nature and disturb nothing. Little can be found that they left behind, except for a few artistic baskets and personal belongings. In the mid-1700s, the Spanish came to occupy coastal California, setting up 21 missions. Between 1812 and 1833, most Miwoks in the area were taken to Mission San Jose by the Spanish—both willingly and unwillingly. Some returned to work the Mexican ranchos, while others died from diseases the Europeans brought with them.

The 1821 Mexican War of Independence gave Mexico the Spanish holdings in California. The Mexican government encouraged the settlement of California by granting large tracts of land. In 1844, the Sanjon de los Moquelumnes land grant was given to Anastasia Chabolla by Manuel Micheltorenia, governor of the Mexican state of California. The grant included a total of 35,508 acres that stretched from the Cosumnes River in the north to the Mokelumne River in the south, and from the Sacramento River in the west to the foothills in the east. Sections of the grant were eventually sold off. Dry Creek Township, where Galt is located, was one of these sections. Two of the early landowners were John McFarland and Dr. Obed Harvey.

In 1852, a man named Chism Cooper Fuggitt founded a settlement he called Liberty after his hometown in Missouri. Liberty was part of the Chabolla land grant and was located on high ground just south of Dry Creek. Liberty served as a stopping place for drayers (freight haulers) on their way to the motherlode with supplies brought upriver from San Francisco to New Hope Landing (near what is now Thornton). It later became a stagecoach stop between Stockton and Sacramento. Within eight years, Liberty boasted a population of 100 people, with a school, blacksmith, hotel, church, and boarding house. But the town of Liberty was short lived, because of another man who purchased a large part of the Chabolla grant.

In 1869, Dr. Obed Harvey succeeded in getting the Western Pacific Railroad (later absorbed into the Central Pacific Railroad) to lay track through his property. Liberty was just a mile southeast but too far from the railroad to survive. Dr. Harvey decided to build a town along the railroad right-of-way. The law stated that anyone could build a town by having the area surveyed and lots sold. The railroad volunteered to lay out the town of 120 acres. The streets had a grid pattern running north and south, east and west. The only stipulation was that there had to be four churches—one on each corner of town.

Another landowner, John McFarland, was given the privilege of naming the new community. He decided to call it Galt after a Canadian town where he had once lived. It soon became obvious the new town of Galt had the advantage over the other small towns nearby. The way of the future lay with the railroad. The town of Liberty faded away.

One

BIRTH OF A
FARMING COMMUNITY

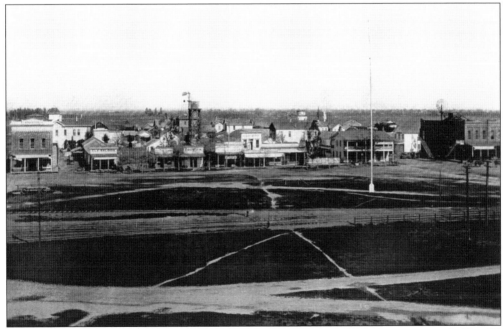

Agriculture and the railroad dominated early Galt. The soil was rich, and water was only 15 to 20 feet below the surface. Shipping surplus agricultural products brought prosperity. Wheat, barley, cattle, and hogs were the money makers. When the Ione connection was made by the railroad in 1876, salesmen and traders frequented Galt. In 1869, the Galt Hotel was built, and the Devon Exchange Hotel was moved from Liberty and placed on Front (now Fourth) Street. The first store was opened by Whitaker and Ray on the corner of Front and C Streets in a building owned by John McFarland. The small town of Galt was growing quickly.

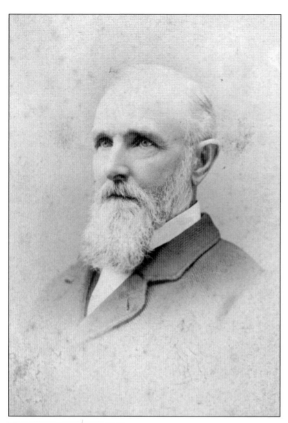

Dr. Obed Harvey attended what is now the University of Iowa Medical School. He came to California during the Gold Rush, but instead of mining, he made his fortune practicing medicine and farming. Harvey became good friends with Charles Crocker, one of the Big Four of the Central Pacific Railroad, and together, they laid out the town of Galt.

The home of Dr. Harvey was located on Second Street between C and E Streets behind his medical office. Slowly turning over his medical practice to others, Dr. Harvey devoted more of his time to his 3,500-acre ranch, his interest in building schools and churches, and to serving in state political office.

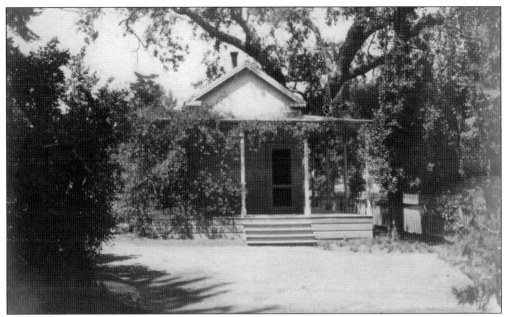

Dr. Harvey set up his medical practice in Galt soon after his arrival. He was one of three physicians who resided in Galt at the time, and his office was within yards of his home on Second Street. This photograph is of Harvey's office during the time it was in use. The office was across from what is now Harvey Park.

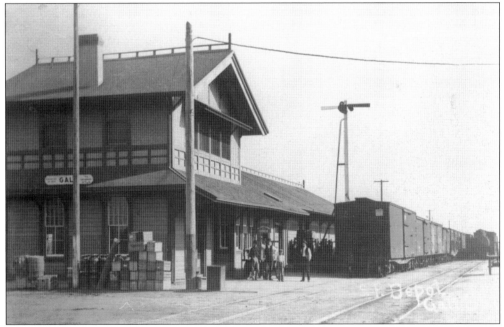

The Galt Depot, central to the existence of town, was on the northeast corner of the rail line and C Street. Typical of most depots, its location was close to the Main Street shops, eateries, and other services. The building was Southern Pacific Company design No. 18, a standard blueprint modified for the use the station would receive in that geographic location. The structure was expanded in November 1925.

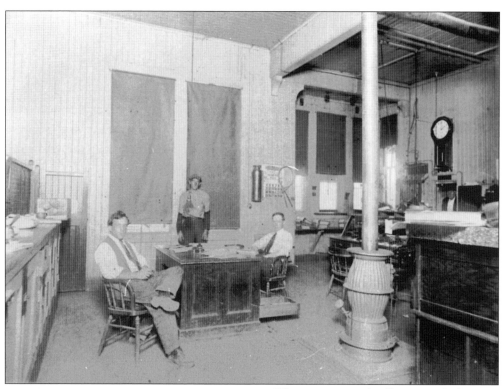

The station agent's office was a fairly roomy area with a pot-bellied coal burning stove sitting in the center of the room. A wind-up clock hung on the north wall, and on the northwest wall was an extended bay window with glass on three sides from which the operator could view train movements. Western Union Telegraph Company equipment, including a telegraph key, was located here, as was a crank telephone that was connected to the Stockton dispatcher's desk.

John McFarland was born in Starlingshire, Scotland, and lived briefly in Galt, Ontario, Canada. In 1850, the lure of the Gold Rush brought him to Placerville, California, where he made his fortune in mining and selling water for mining purposes. In 1857, he traveled to the Sacramento Valley and bought 1,600 acres of farmland northwest of what would become Galt, California.

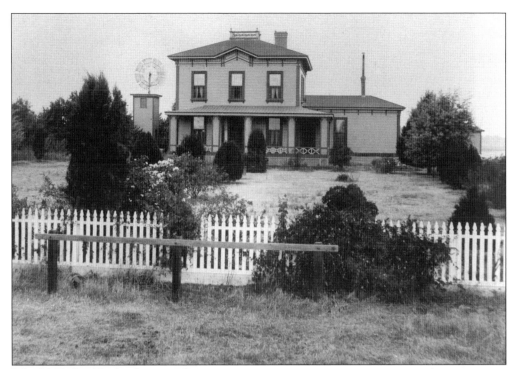

John McFarland built a home on his newly purchased property in 1878. Other buildings on the property included a barn, a tank house, a blacksmith shop, and corrals. McFarland became a prominent member of the Galt community and, because of his carpentry background, helped build or fund the construction of many of its buildings.

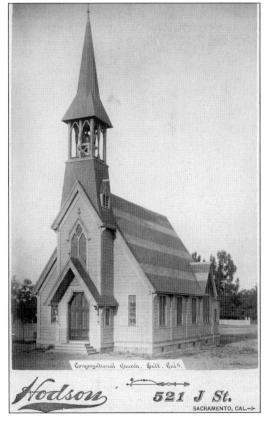

One of the original churches built in Galt was the First Congregational Church (later to become St. Luke's Episcopal Church) on the corner of Third and B Streets. John McFarland and Dr. Obed Harvey were the men behind the efforts to raise funds to build what would become the third church in town. (Judy Jacobson.)

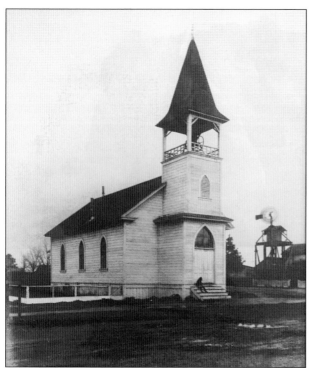

In 1880, when the Hicksville congregation moved to Galt, the United Methodist Church of Galt was founded. It was located close to Seventh and F Streets and was the second church to be placed in the town of Galt as was agreed upon by the railroad and Dr. Harvey. At that time, the church was served by a Methodist circuit rider who came through Galt on his route to bring the word of God and to "marry and bury."

In 1857, the Christian church was built in the little town of Liberty. It is said to be the first church in the area. When the town of Galt was created, Liberty began moving its buildings (including the church) into the new town. In 1878, the Christian church was placed at a corner of the original grid, now Seventh and B Streets.

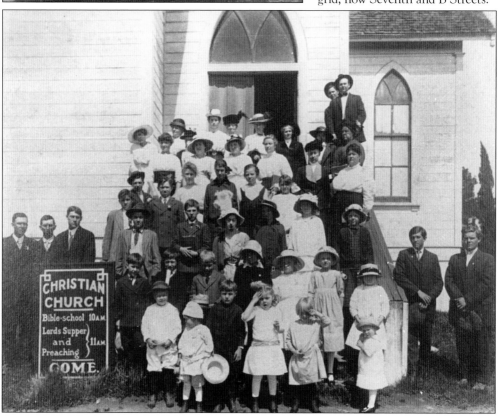

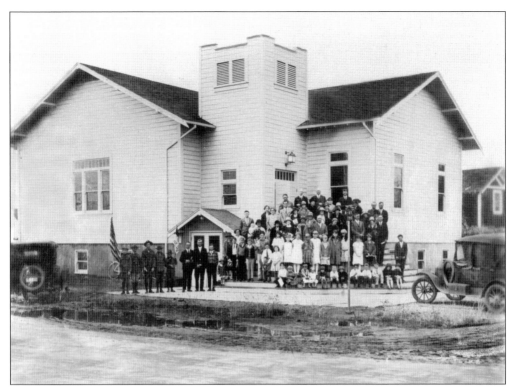

As the Christian church grew, its windows leaked, and woodpeckers nested in the bell tower. In 1925, a basement was added as a meeting hall. William Hobday told how difficult it was to remove dirt without damaging the church structure. The original church was constructed of lumber that came around Cape Horn. That lumber is still in use as the main body of the church.

On October 12, 1885, the brick St. Christopher's Catholic Church was built and dedicated in Galt at the corner of Third and F Streets. St. Christopher's finished the four promised churches, each on a corner of the original town grid. As it happened, the day of the dedication was also the 393rd anniversary of the discovery of America by Christopher Columbus, so the congregation chose the patron saint of travelers, Saint Christopher, as the name of their church.

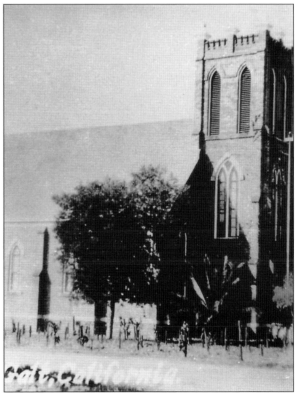

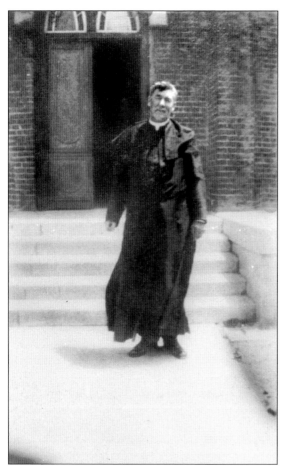

Fr. Thomas Francis Dermody was St. Christopher's second priest after Fr. James Grealy. Before Grealy and Dermody, the church was serviced by the priest from Jackson. Born in Ireland, Father Dermody came to this country in 1923 and served St. Christopher's for four years before passing away.

This baptism ceremony took place in Dry Creek around 1900, most likely by the Christian Church. According to Christian beliefs, baptism washes away sins and gives spiritual life. This baptism seems to have taken place during mid- to late spring, as that is the only time Dry Creek has water and good weather.

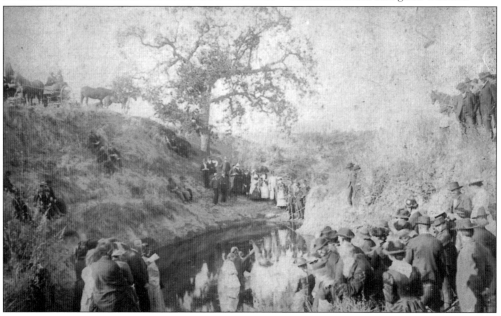

In 1876, John Brewster opened a store in this building that John McFarland built. He sold general merchandise while also buying and selling wheat. Located on the corner of Fourth and B Streets, Brewster's store would be the first of many general stores to occupy the building. The Brewster building still exists and currently houses a restaurant.

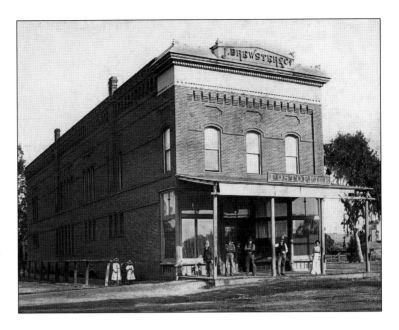

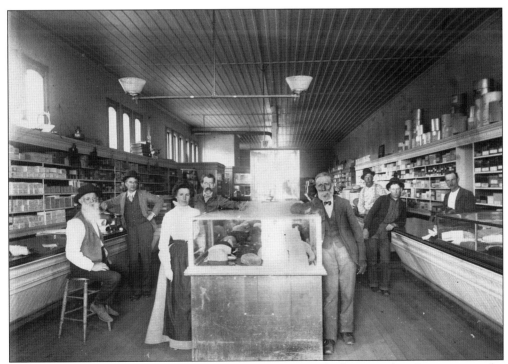

This is the interior of Brewster's store as it appeared in its early days. Caroline Brewster is at the left of the cabinet; John Brewster is on the right. In 1869, the US post office was established in the same building, with John Brewster appointed as the first postmaster. Eventually, the Independent Order of Oddfellows (IOOF) would occupy the second floor as their lodge.

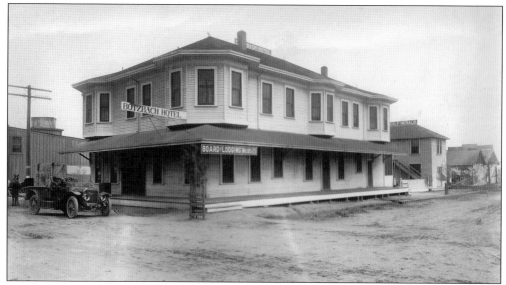

Hotels were one of the first businesses in a new community, and one of the first to open in Galt was the Botzbach Hotel. It was located on the corner of Fifth and C Streets where Compadres Market is now. Right behind the Botzbach Hotel is the *Galt Herald* office, and behind that, a movie theater was erected, later to become the Valley Oaks Grange. (Judy Jacobson.)

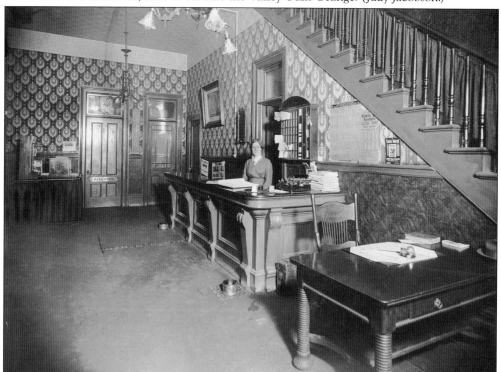

A friendly desk clerk awaits the next customer in the lobby of the Botzbach Hotel. The going rate for a room at the time was between $2 and $4 per night. According to the sign outside the hotel, meals were 25¢. Fresh linens were provided by the Chinese laundry located on Fifth Street between B and C Streets.

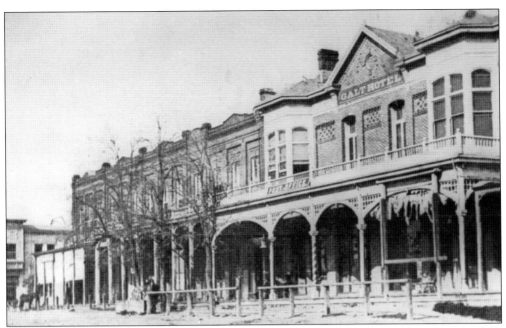

Another of the early hotels in town was the Galt Hotel located on Fourth Street just south of the C Street intersection. This early photograph shows hitching posts for horses and the large number of brick buildings. Fires damaged many of the early wood structures, so brick became the building material of choice. This section of town became known as the Ray/Whitaker Block.

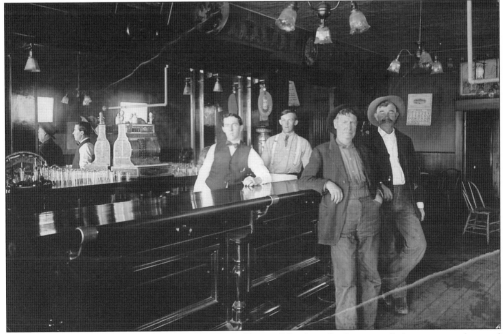

No town would be complete without its friendly neighborhood saloon, and this one was housed inside the Galt Hotel. Saloons in small towns like Galt were much quieter than in larger Western towns where a gunfight might break out. Patrons were more likely to sit and slowly sip a nickel glass of beer and snack on pickles set out by the bartender.

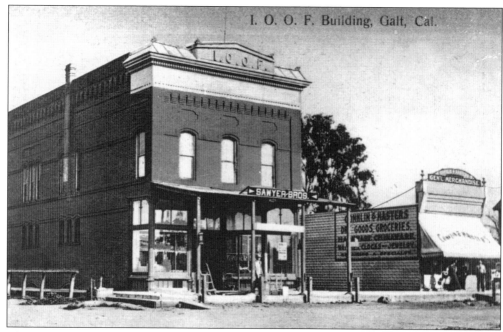

This was the second use of the McFarland-built brick structure on Fourth and B Streets, now called the IOOF building. The building changed hands a few times over the years. After John Brewster, James and Mary Bethel purchased the structure before selling it to Sam Wriston. The Oddfellows then purchased the building from Wriston. The Sawyer Brothers general store was on the bottom floor.

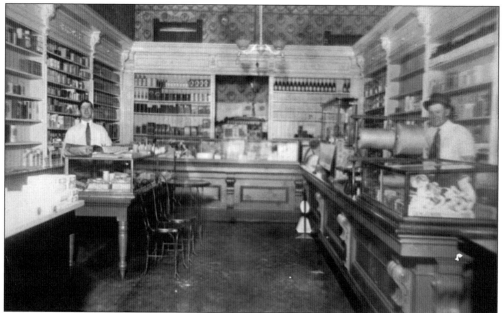

This is the inside of the Sawyer Brothers store. By the time of the opening, the needs of the customers had changed. The general store no longer stocked meats, produce, baked goods, or hardware, as there were other stores to supply those items. Now, Sawyer Brothers supplied canned and boxed goods, tobacco products, and sundries of all kinds.

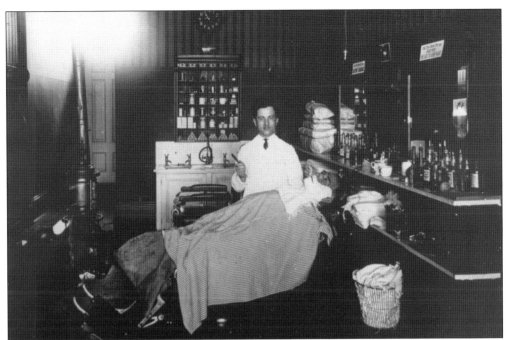

Pictured is Sonny the barber posing before starting his straight razor shave of another customer. Galt had two barbershops in the early days. These shops were as much a fixture in town as general stores and saloons. Usually, shaves were 10¢ and a haircut was two bits (25¢). One could tell how successful a barber was by the number of personalized shaving mugs he had on display.

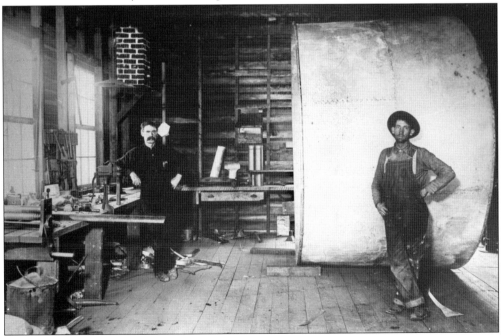

Two tinsmiths pose in the early 1900s. A tinsmith made things out of tin and other light material such as pewter. Most of the items a tinsmith made, such as cookie cutters, pie pans, and pails, were made from cold materials, unlike a blacksmith, who worked with hot metals like iron.

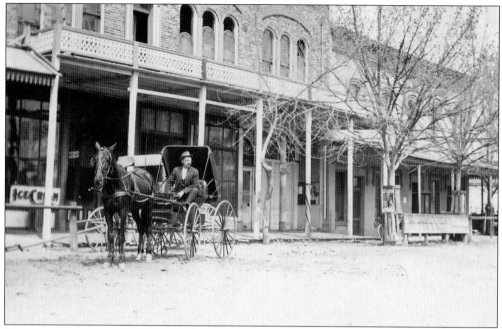

This is a street scene of Front Street between C and E Streets. The man in the buggy is stopped in front of one of two general merchandise stores in Galt at the time. On the right is the Galt Hotel. Notice the ice cream sign and no evidence of electrical power. The ice cream must have been hand-cranked.

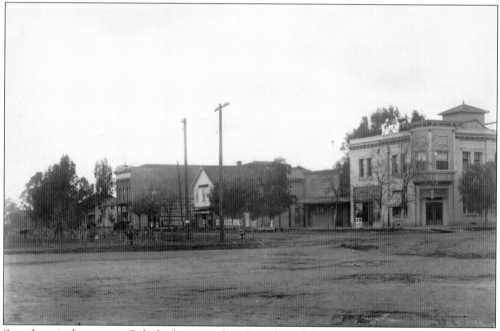

Seen here is downtown Galt, looking north at Fourth and C Streets. Front Street (now Fourth Street) was the center of business, as farmers brought their cattle and hogs to the stockyards south of the station to be shipped to the East. Sacks of wheat and barley could be seen piled high waiting to be picked up for shipment to the mills. (Judy Jacobson.)

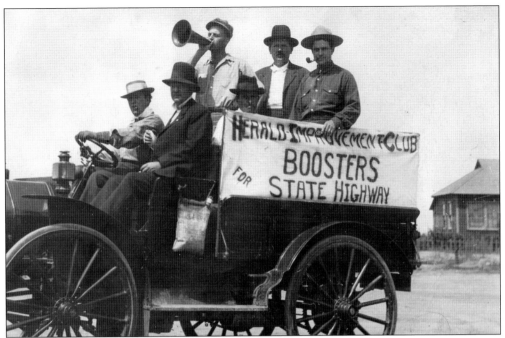

Boosters from the Herald Improvement Club provide publicity for the Lincoln Highway, which would eventually pass through Galt. The Lincoln Highway was one of the first transcontinental roads in America, stretching from New York City to San Francisco. The official length of the highway in 1913 was 3,389 miles. (Judy Jacobson.)

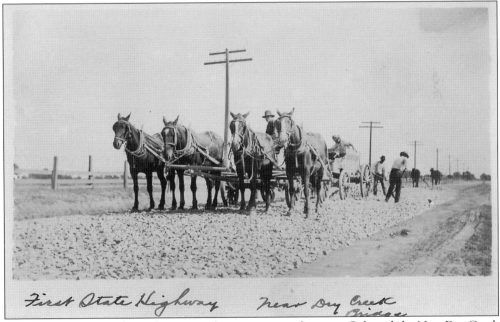

First State Highway near Dry Creek Bridge

A section of the Lincoln Highway is under construction between Galt and the New Dry Creek Bridge. The highway would continue south on what is now Lower Sacramento Road past Lodi and into Stockton, where it turns and follows most of modern Interstate 580 and heads on toward San Francisco. (Judy Jacobson.)

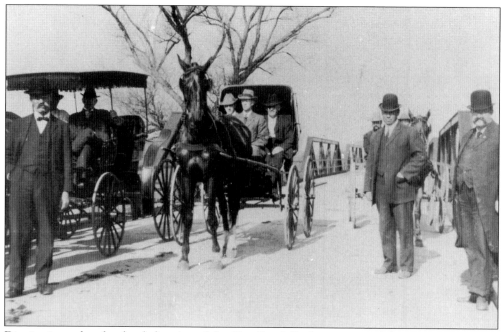

Dignitaries gather for the dedication of the Dry Creek Bridge portion of the Lincoln Highway. In the buggy driven by Constable Rollo Brewster, Galt's first constable, is California governor Hiram Johnson. The bridge was the final link to the completion of the highway and marked a change in Galt. The California section was about 235 miles long.

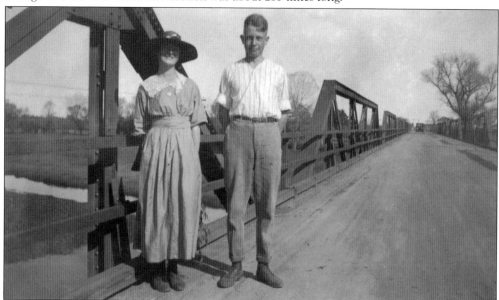

Leland Maxwell and a friend pose on the new Dry Creek Bridge portion of the Lincoln Highway. For Galt, the Lincoln Highway, known at that time as "the Main Street Across America," was to change the town's character forever. Instead of Fourth Street and the railroad depot being the heart of Galt's commercial area, it was soon apparent that Galt's businesses were going to move to the east near the new road. Garages, cafes, and other tourist stops soon lined the Lincoln Highway as it passed through the town.

Two

AMBER WAVES OF GRAIN

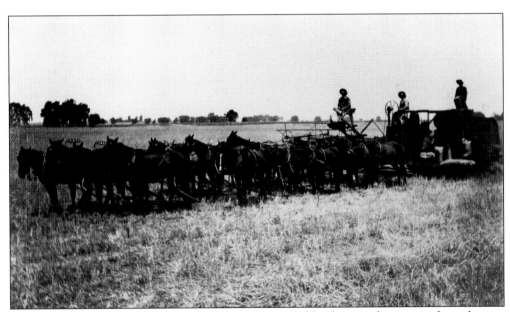

Galt always has been a farming community producing crops like clover seed, grapes, and strawberries, but in the beginning it was wheat. Spanish missionaries from Mexico brought it with them to plant around the missions. Wheat became a hot commodity with the coming of the Gold Rush. Miners from all over the world wanted bread and pastries that only wheat could provide. Like a lot of farmers new to California, John McFarland and other Galt area growers saw the need and began producing wheat for the masses.

John McFarland was one of the major land holders in the Galt area. His ranch was located northwest of Galt and consisted of 1,600 acres with 1,400 acres in cultivation. Wheat was his major cash crop with barley and oats coming in a close second. With the money he made from farming, McFarland helped construct buildings in town and contributed to churches and schools.

George Orr was born in Ontario, Canada, on October 20, 1864. At the age of 19, he came from Canada to Galt, where he went to work for John McFarland. Two years later, he married Mary McFarland, John McFarland's niece. Orr was known as a shrewd businessman and farmer. He was vice president of the Bank Of Galt until his death.

At first, George and Mary McFarland Orr lived in the house John McFarland built for them a half mile east of the McFarland Ranch. He later asked the Orrs to move in with him, which they did. It was there that the Orrs raised their five daughters. George continued to farm McFarland's ranch after McFarland's death.

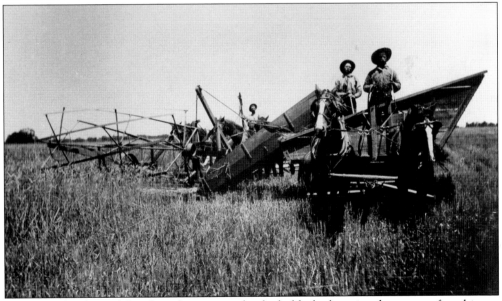

John McFarland's ranch hands are harvesting what looks like barley using the newest of machinery. By 1888, wheat planted on California farms approached three million acres, placing the state second in the nation. At one point, California exported two million tons of wheat. John McFarland made his second fortune in the production of wheat and other grains. (William Orr Bland.)

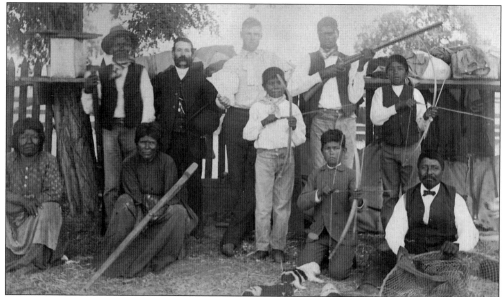

Plains Miwok Indians worked on John McFarland's ranch from the early days. The use of indigent people in the area started with Spanish missionaries along the coast and spread into the interior. Early California settler John Sutter was a big proponent of Miwok labor, and John McFarland followed his lead. It appears that McFarland treated his workers better than Sutter, who was known for his mistreatment of the Miwoks.

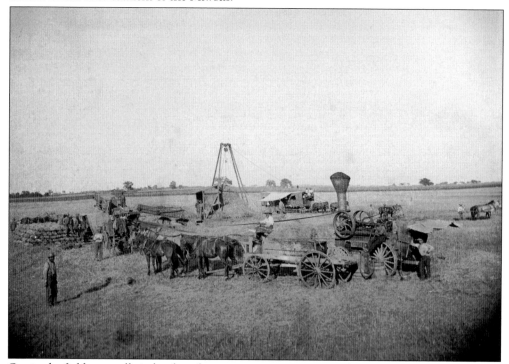

Out in the fields, a small circle of machinery was set up to process the grains that were harvested. On the bottom right is a steam-powered threshing machine. In the background is the McFarland Ranch version of the chuckwagon. In the middle is a pile of chafe waiting to be recycled.

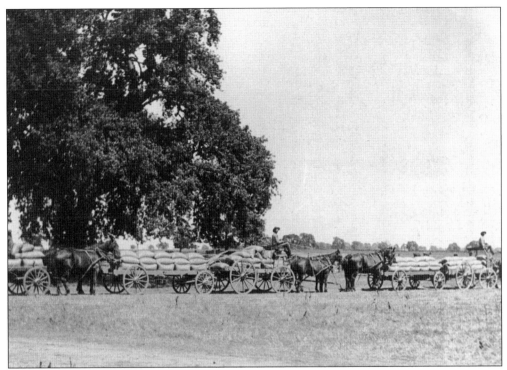

On their way to the railroad station are wagons full of processed wheat or barley. Soil exhaustion, along with low farm prices, led to the reduction of wheat farming. Because of the Mediterranean-type climate, some farmers switched to barley, while others let their fields go to pasture for dairying or cattle ranching.

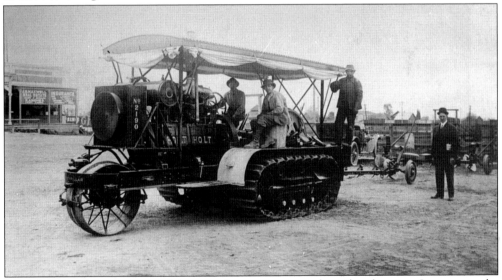

One of the local farmers gets a shipment of a new tractor at the railroad station. It appears to be sitting on Front Street near D Street at the end of the block. This tractor came from the Holt Manufacturing Company of Stockton, California. Benjamin Holt experimented with continuous track–type tractors like this one around the turn of the 20th century. At one of his tests, an observer commented, "She crawls along like a caterpillar." A name was born.

Alice McCauley Valensin was the daughter of wealthy Galt area landowner John McCauley. On a trip to Europe, she married a well-to-do Italian named Julio Valensin and brought him back to the McCauley ranch. During the life of her husband, the Valensin ranch was devoted to the raising of racehorses, but after his death, she converted the entire ranch into a cattle and grain farm.

Alessandro "Alex" Marengo came to the United States on the heels of his father, who settled here in 1879. Of the 784 acres of land his father purchased northeast of Galt, Alex bought 160 acres and inherited another 160 acres when his father died. Later, he bought the ranch house and continued to farm the ranch his father started. Pictured from left to right are Gus, Tony, Alex, and Joe Marengo and an unidentified little boy. (Linda Fletcher Burge.)

Amadeo and Guidita Lippi established a thriving business through hard work and dedication. Amadeo, a descendant of Italian renaissance painter Filippo Lippi, established a truck farm and winery at the southern end of Third Street. The Lippis had five children: George, Pio, Clara, Sylvia, and Rosie. Prohibition ended the winery business but, after its repeal, the winery reopened as the Galt Winery.

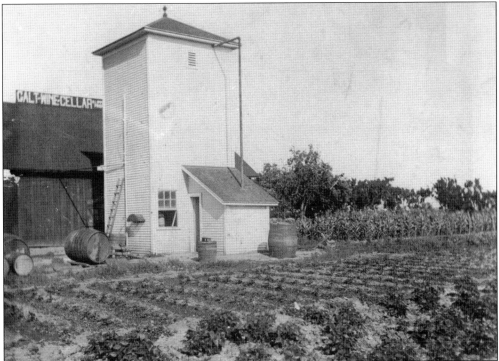

In 1906, Amedeo Lippi saw a need for fresh fruits and vegetables in the community, so he installed an irrigation system and planted a truck garden. A truck garden, sometimes called a market garden, is planted on a few acres with a diverse selection of produce to sell locally.

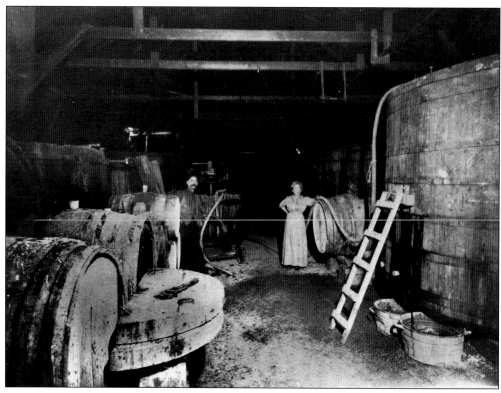

Born in the Italian province of Lucca where he learned winemaking, Amedeo Lippi started his own winery in Galt in the early 1900s. Along with his wife Giuditta, Lippi crushed grapes from his own newly planted vineyard and bought train gondola loads from outside the area. It was a very profitable enterprise until Prohibition shut it down.

Charles Ambrogio came to this country from Switzerland in 1890, settling in Galt in 1906. Ambrogio became partners with Dr. Obed Harvey and his son Fred at the Harvey Ranch in the same year. The Ambrogios established a large dairy herd and were one of the first to supply milk to the Sego Milk Company. Every year, Charles Ambrogio organized Swiss picnics at the site of what is now Fairsite School.

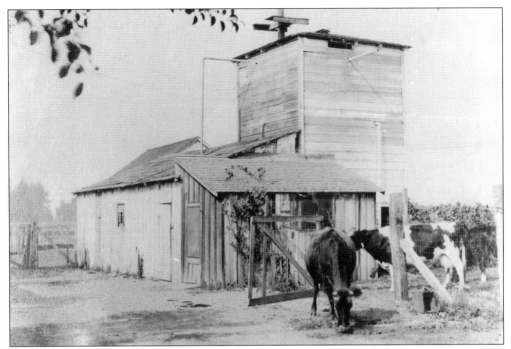

Charles and Clementina Ambrogio lived on the 3,000-acre Harvey Ranch for 12 years (1906–1918) before purchasing the old Hull McClory place on the western outskirts of Galt. They established a dairy with between 200 and 300 cows. The Ambrogios made their own cream and cheese and not only sold it locally, but also made regular shipments to San Francisco.

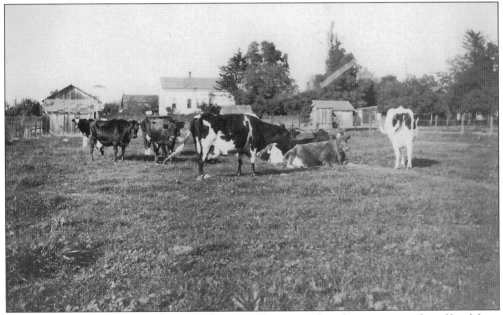

When Charles Ambrogio died in 1920, his wife Clementina bought a two-acre plot of land from Billy Hicks on Oak Street. The John Rae House (later the Rae House Museum) can be seen in the background. They grew alfalfa and milked 10 cows. Clementina Ambrogio called it the Ambrogio Dairy.

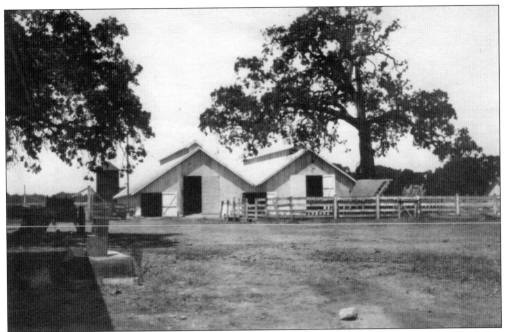

Fred Harvey, son of Dr. Obed Harvey, was a graduate of the University of California, Berkeley School of Engineering. He owned a coal mine near the extinct town of Carbondale, California, but his interest was in the dairy business. He had one of the larger dairies in the Galt area as part of the larger Harvey Estate. Fred Harvey also served on numerous dairy committees for the American Farm Bureau. (Cleo McAllister.)

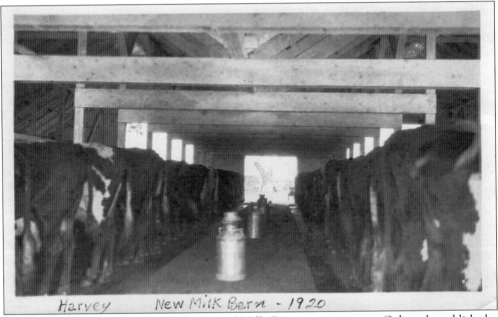

Harvey New Milk Barn - 1920

Fred Harvey convinced the Utah Condensed Milk Company to come to Galt and establish the Sego Milk Company in 1917. With a new customer to send his milk, Harvey made enough money to build himself a new dairy milking barn. Genevieve Harvey continued to send Harvey milk to the Sego plant after her brother Fred's death. (Cleo McAllister.)

A local Galt dairy farmer who started from humble beginnings was Martinus Vandenburg. He, along with his wife, Wilhelmina, son Leonard, and daughter Ria moved to the United States in 1955 traveling by ship from the Netherlands to New York's Ellis Island. The Vandenburg family made their way to Galt, first renting the Russell Ranch and then purchasing another dairy on Kost Road to build his herd. Martinus (wearing wooden shoes) is pictured with his first cow. (Wilma Vandenburg Bianchi.)

Gottardo and Maria (Tonella) Barsetti arrived in the Galt area in 1912. Originally from Ticino Canton, Switzerland, the Barsettis purchased a small farm near Herald where they farmed and started a dairy. Gottardo was reported to be the first dairyman to ship his milk to the newly opened Sego milk plant in Galt in 1917. In 1941, Gottardo, Maria, and son Henry purchased 300 acres of land on Cherokee Lane near Liberty Road, where they continued to run the dairy. (Janis Barsetti Gray.)

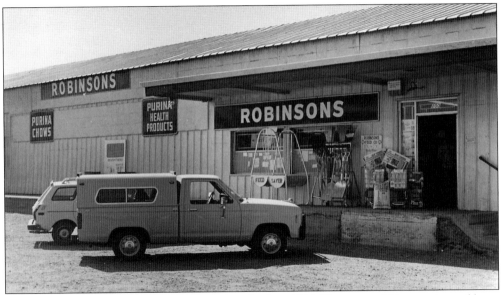

William Robinson founded Robinson's Feeds in Lodi in 1906. The store sold hay, grain, and later, wood and coal to local farmers. William's son Willard took over the store and added a number of additional items, including poultry supplies. In 1946, Willard's son-in-law Ed Olson (who married Evelyn Robinson), son Emory Robinson, and nephew Leroy Weaver, all back from World War II service, bought the business from Willard. Within 10 years, Ed and Evie Olson bought out the other two partners and expanded the business, opening this store in Galt. (The *Galt Herald*.)

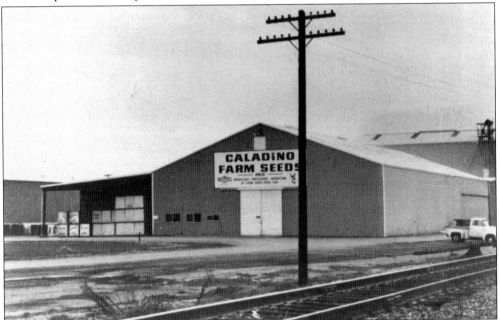

Caladino Farm Seeds was constructed in 1959 and hailed as the most modern and efficient seed-processing facility in the United States. Located on Twin Cities Road, the company changed its name to Cal/West Seeds in 1969. Caladino-Cal/West develops, produces, and markets crop seeds. It offers alfalfa, clover, safflower, and sorghum seeds, to name just a few of its products. (The *Galt Herald*.)

Three

READING, WRITING, AND ARITHMETIC

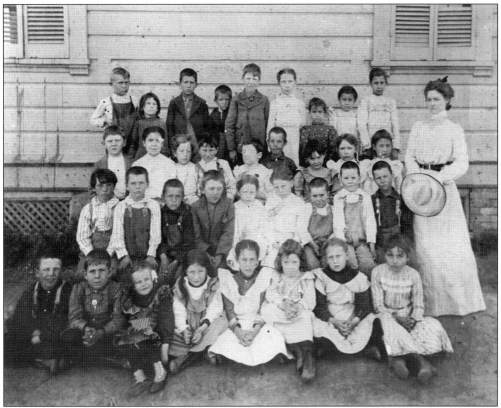

Horace Mann was a Massachusetts congressman and education reformer. Credited as the "Father of Public Schools," Mann believed that every child needed an education to keep them disciplined. But the schools at the time were primitive, and most of those were one room with a single teacher who taught first through eighth grades together. The youngest students sat in the front, while the oldest sat in the back. A single wood stove heated the room. Most teachers had a limited education and were paid a menial salary. Most schoolhouses were built to house the students who lived within four or five miles, which was considered close enough for them to walk.

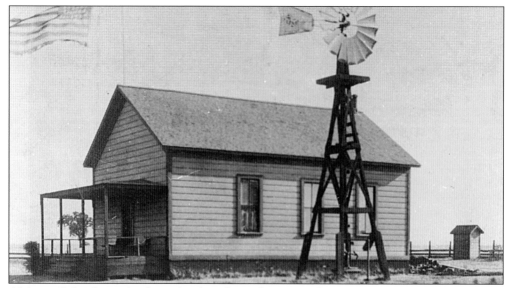

Alabama School was the first school in the Galt area. Built in 1869, it was one of many one-room schools in the area. The school was located on Alta Mesa Road near Altua, because that location was on high ground and was central to all the rural farm families. It burned to the ground in 1918.

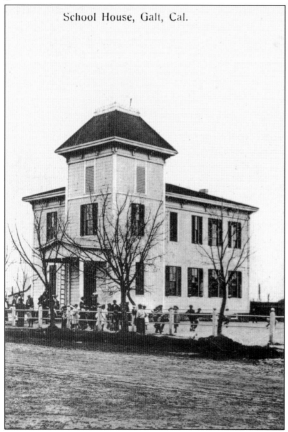

School House, Galt, Cal.

Galt Grammar School was the first school built in Galt and was located between Fifth and Sixth Streets on B Street. The two-story structure had grades one through four on the first floor and grades five through eight on the second floor. It served the community for over 35 years and was built with money donated by railroad tycoon Charles Crocker and Dr. Obed Harvey in 1879. In 1915, it was torn down to make way for three homes.

Built at a cost of $900, the Arno Public School opened in 1891 and taught students for the next 66 years until it finally closed in 1957, when most of the students were sent to the new Arcohe School. It was the typical one-room schoolhouse, which was the norm in those days.

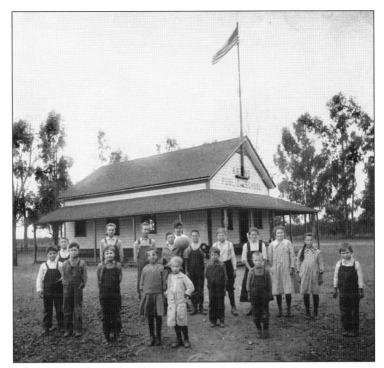

Located on Lower Sacramento Road between Collier and Liberty Roads was Liberty Elementary School. It educated the children from the neighboring town of Liberty and then, when the town was abandoned, the rural students of the area. It was annexed into the Galt Elementary School District in the 1940s.

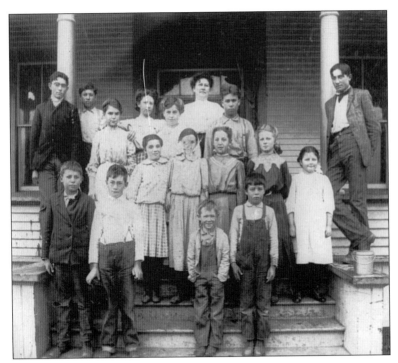

Students of the Brown Elementary School student body pose for a photograph outside on the front steps of the school. This one-room schoolhouse was located on Clay Station Road, a half mile south of Borden Road and eight miles east of Galt. A large porch across the front with wide railings was a favorite place to sit for the students.

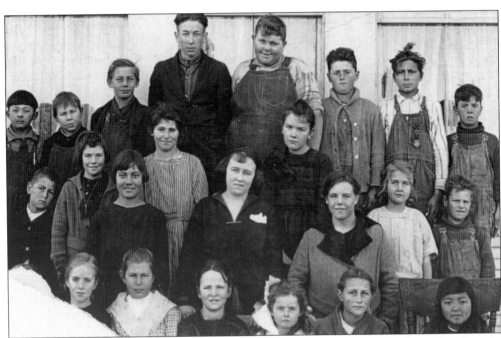

Showing the diversity of their student body, the Telegraph School in northern San Joaquin County was the southernmost school to feed into Galt High School. Located in the vicinity of its replacement, Oak View School, Telegraph accepted some of the students from the now abandoned town of Liberty.

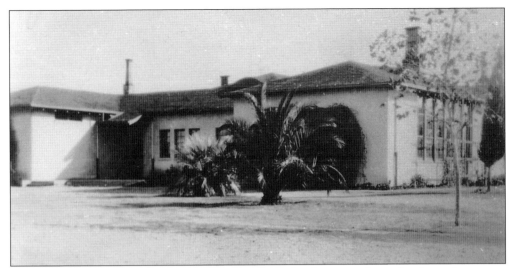

For many years, Galt Grammar School was the only school in town. It was first housed in a two-story structure on B Street and then moved to a new structure where the building and playground filled an entire square block between Fifth and Sixth Streets and E and F Streets. Until 1948, this was the Galt Joint Union Elementary School District. Later, a new elementary school site was created to house grades three through eight. Kindergarten through second grade remained at the E Street site and was known as Galt Primary School.

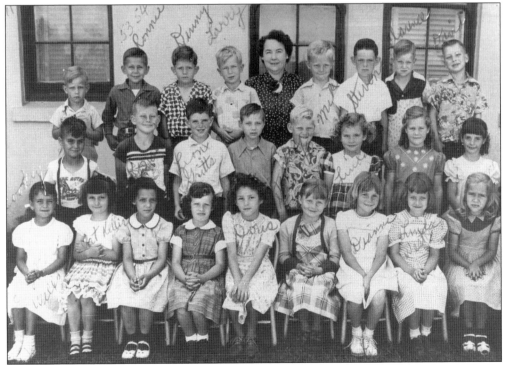

Alma McKinstry poses with her second-grade class at Galt Primary School in the late 1950s. By this time, McKinstry had taught for 30-plus years and had seen the transition of the school from kindergarten through eighth grade to just kindergarten through second grade. She retired shortly thereafter and passed away in 1962.

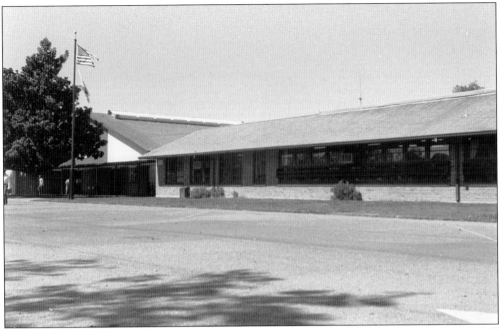

The new Galt Elementary School was built on C Street in 1948. By the 1970s, it became too small to contain the growing number of students moving to the Galt area. A middle school was now needed for the older students. Galt Elementary School was torn down and became a shopping mall. River Oaks Elementary School and Vernon E. Greer Middle School were built to replace it.

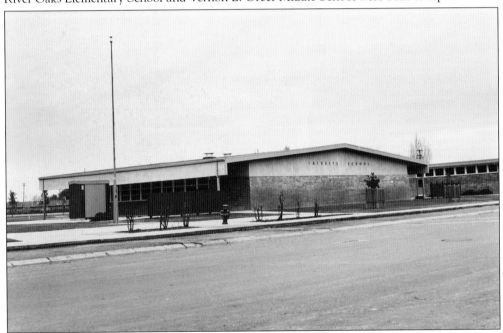

Built on the former site of the Sacramento County Fair Grounds, Fairsite School was built to help replace the old Galt Elementary School on E Street. Fairsite got its name in honor of the former fairgrounds. Because of lack of enrollment, Fairsite School closed down, and the property is now used as a preschool and for auxiliary education.

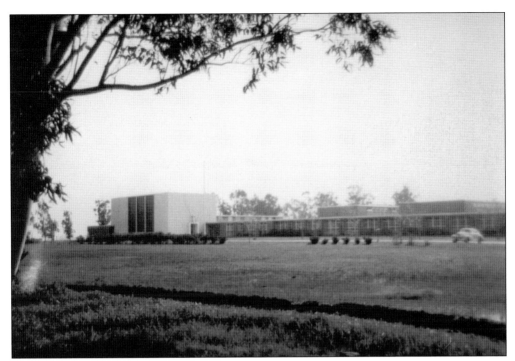

Built in 1959, St. Pius X Minor Seminary moved from Humbolt County in northwest California to the Twin Cities Road site in 1961. The land was donated by the Need family to the Catholic Church. The school housed 200 students a year and had a 28-foot-by-36-foot stained-glass window. The school closed in 1977.

Standing in front of the middle school that bears his name, Dr. Robert L. McCaffrey poses for a photograph with local community activist Dixie Johnson during the dedication ceremonies. McCaffrey was principal at Arcohe School and a teacher at Galt Elementary School before becoming superintendent for the Galt Joint Union Elementary School District for close to 30 years. (The *Galt Herald*.)

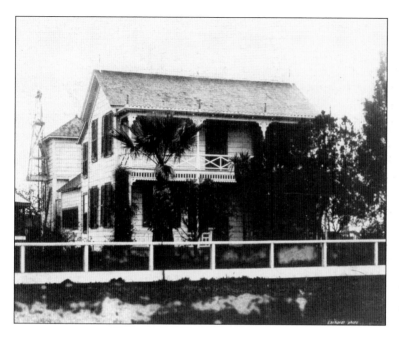

At the corner of Fifth and D Streets stood a two-story house that was to be the first high school building. A faculty of three met the first students. John Reese was the principal and also taught classes. William Bland, who was to become the principal later, taught mathematics, bookkeeping, and music. Miss McFarland taught English, Latin, and composition.

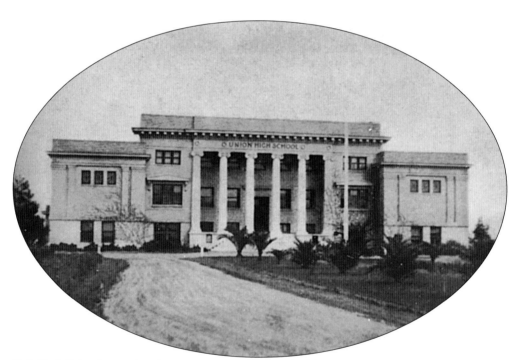

Galt High School moved to the present site with a new building in 1913. The new school was built with the issuance of bonds of $30,000. This represented about a third of the cost. The second Galt High School was an imposing two-story brick structure with Greek columns supporting the entrance. An expanse of lawn and a driveway lined with palms offered a pleasant entry to visitors and students. Twenty-two students were present on the first day of school.

The Buzz was the student annual for Galt High School starting in 1918. The annual, or yearbook, highlights and records the past year of a high school. Pages might include pictures of classes, sports teams, and clubs. The staff were mostly those students interested in journalism plus a faculty advisor. Galt High School's yearbook eventually became *Hi-Lights*.

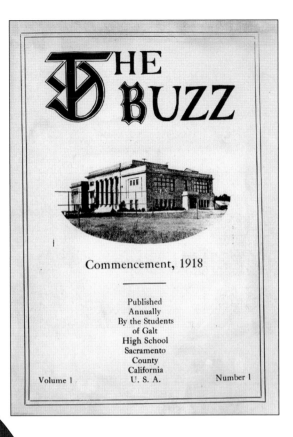

THE BUZZ

Commencement, 1918

Published
Annually
By the Students
of Galt
High School
Sacramento
County
California
U. S. A.

Volume 1 Number 1

William Bland was the principal of the second Galt High School. Originally from Thorner, England, Bland came to this country and settled in El Dorado County in 1888. His English teaching credentials were not recognized, so he had to reexamine for this state. After working in Placerville for a number of years, William Bland settled in Galt around 1913 and became principal of the new Galt High School for 10 years.

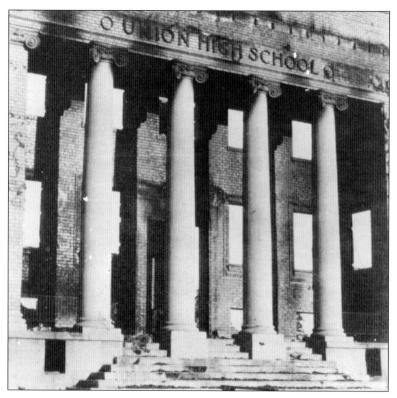

In June 1924, a mysterious fire destroyed the once great main building of Galt High School. Galt's volunteer firemen responded to the call but were unable to save the structure. The cause of the fire was never determined, and the 10-year-old building was considered a total loss. Charred ruins were all that remained. Other buildings on the property survived and became a basis for the next version of the high school.

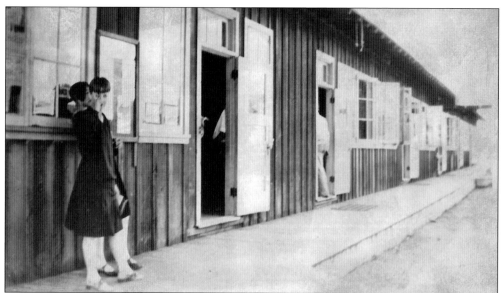

The district recovered from the shattering blow of the fire that destroyed the main building in 1924. Galt High School opened in September of that year in temporary buildings that were to be home to students for the next three years. The students referred to these temporary quarters as the "Chicken Coops."

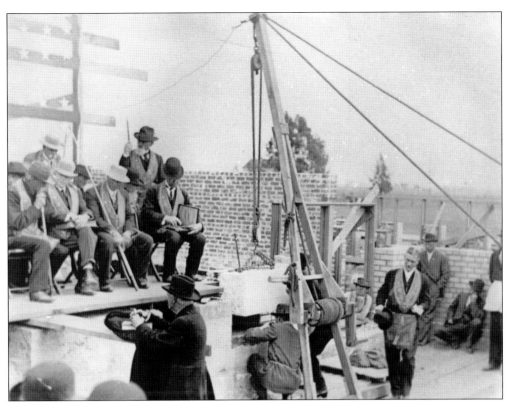

Planning started on a new building. Dean & Dean of Sacramento was the architect firm. Out of its plans came a two-story Mission-style schoolhouse. The cornerstone-laying ceremony took place on March 12, 1927. A parade from Fourth and B Streets led the way to the site. Galt Masonic Lodge No. 257 conducted the rites with George Jones, grand master of California; and Fletcher Cutler, grand orator in charge. Scoutmaster J.L. Orvis and Boy Scout Troop 1 supervised the parade.

Workers continue working on the new main building of Galt High School. Trying to fund the construction of the new high school was time consuming. Three school bonds were defeated before it finally passed on the fourth try. With a price of $100,000, the music, industrial arts, and agriculture buildings were added later.

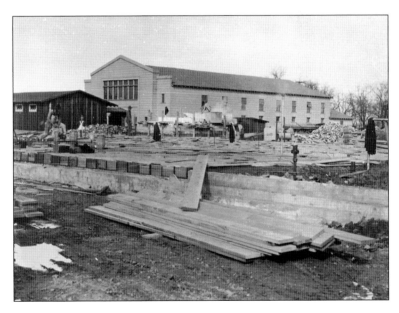

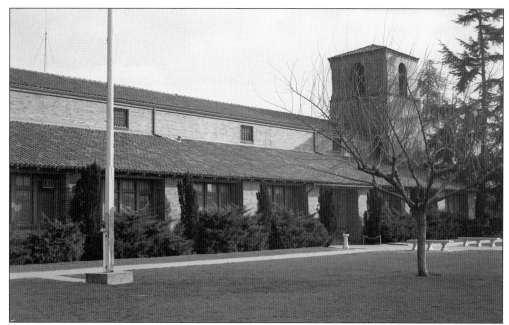

The third Galt High School was completed in 1927 and dedicated on February 8, 1928. The building, designed for 300 students, was constructed so additions could be made. The main building was never enlarged, but outlying buildings took care of the growing student body. The auditorium seated 600 and was well equipped at the time it was built. The cafeteria could handle 150.

The old Galt High School gym was built in 1942 and resembled an airplane hangar but has endured the last 74 years. Former teacher and basketball coach Donald F. Nottoli was a 40-year fixture in the halls of Galt High School and was honored with the renaming of the old gym as the Nottoli Dome. Coach Nottoli passed away in 2006. (The *Galt Herald*.)

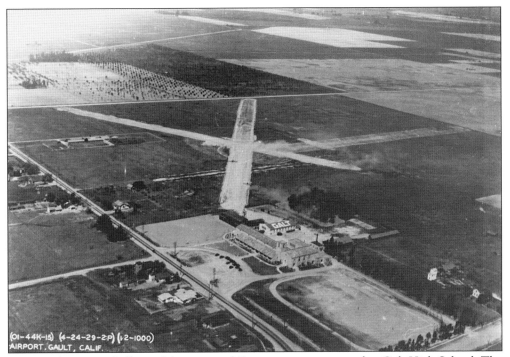

In 1928, the Junior College of Aeronautical Engineering was created at Galt High School. The flying field was a 78-acre plot with four well-graded landing strips and a quantity of engines and parts valued at $175,000. Looking at the site today, the airstrips would be over State Highway 99 and the property on the other side.

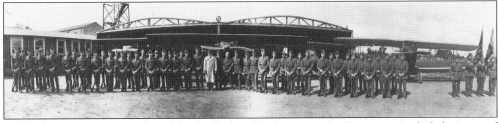

Only 75 young men were selected for the flight school out of 600. The courses included science of aeronautics, weather observation and forecasting, navigation, and engine design and construction. Thirty-two students were enrolled in these aviation classes, with two faculty members in these areas. The students flew daily with a licensed copilot.

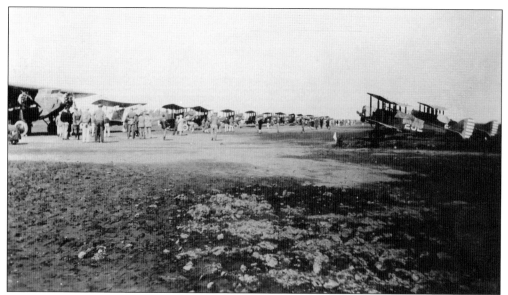

The planes used at the Galt Junior College of Aeronautical Engineering included the Eaglerock, a two-seat biplane manufactured by the Alexander Aircraft Company, and a Jenny, a World War I Curtiss JN-4 biplane. Eaglerocks were produced mainly for crop dusting, carrying airmail, and aerial photography. The Jenny was produced for training airmen during World War I. The students owned the Eaglerock.

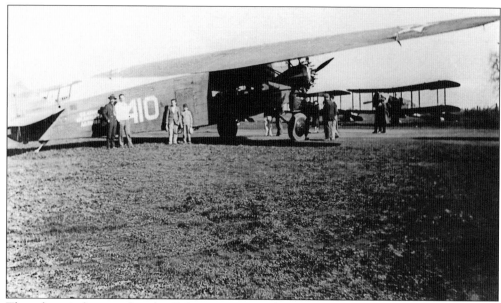

The other airplane used at the Galt campus was a large Navy M-O monoplane (Martin MO) manufactured at the Glenn L. Martin Company of Cleveland, Ohio. The MO was manufactured for the US Navy for the purpose of sea and ground observation. It had a thick airfoil cantilever wing and three seats. Thirty-six were built in the early 1920s.

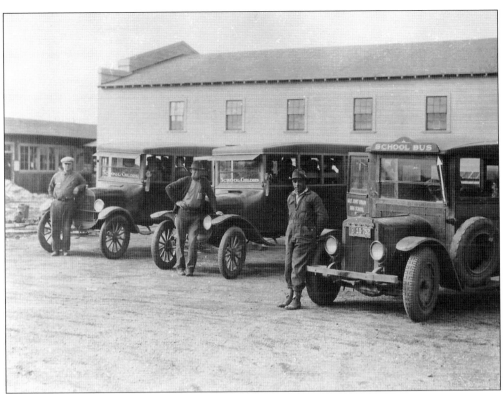

There were few social events those first few years at Galt High School because of the lack of transportation. Most of the rural students rode horses to school, although a few did have cars. Most of the roads were not paved. Beginning in the mid-1920s, a bus fleet was established that would enable most of the rural students access to school and events.

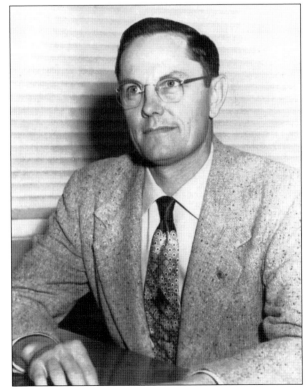

Orvell K. Fletcher was an institution at Galt High School for 24 years. He served as principal and superintendent from 1954 until 1967 when Laurence Littleton replaced him as principal. Fletcher stayed on as superintendent until 1978, when he retired and went into politics, serving on the Galt City Council. Orvell Fletcher is credited with modernizing the city schools.

In 1937, Laurence Littleton was the music teacher responsible for organizing the first Galt High School band, orchestra, and chorus and holding that position for the next 30 years before taking the principal job in 1967. He retired from education in 1977. Littleton is pictured at one of the Lions Club events he enjoyed. (The *Galt Herald*.)

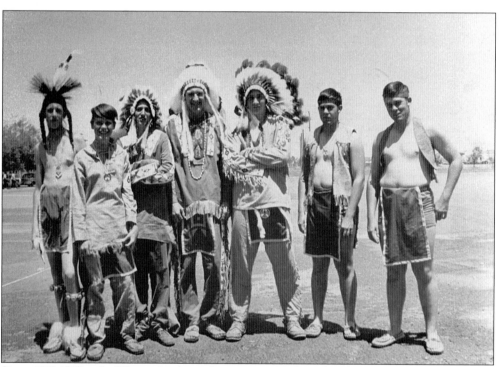

Since 1937, Willie the Warrior has been the mascot of Galt High School. There have been times that the caricature of Willie has come under fire and has been changed to a more representative symbol of Native Americans. This is a group of Native American–themed dancers at a high school cultural event.

Four

COOKIES AND MILK

Towns up and down California are noted for a business or two that is unique to that community both today and in the past. San Francisco has the Ghirardelli Chocolate Company and the Golden Grain Macaroni Company (Rice-a-Roni). Lodi had a General Mills plant that made cereal and had an Italian Swiss Colony winery. Stockton had the Sperry Flour Company, and Manteca had the Spreckels Sugar plant. Galt had a business that once was, the Sego Milk Company, and a business that still thrives, Spaans Cookie Company. (Jim Spaans.)

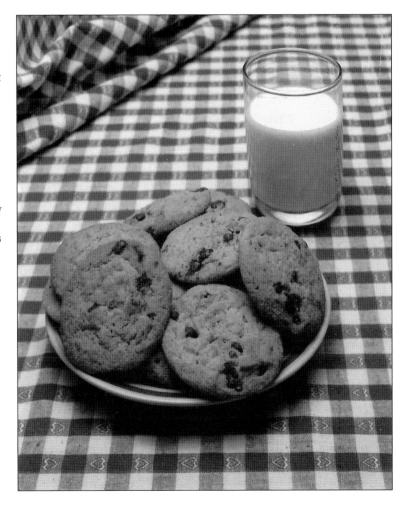

In 1917, Galt was the center of a large agricultural area dotted by many dairy farms with milk needing to be shipped to market. Fred Harvey was a dairyman who saw the need for a closer market. He was responsible for enticing the Utah Condensed Milk Company to establish a plant in Galt. Harvey and the dairy and business interests of Galt worked to obtain the property near the railroad tracks on which the Sego milk plant could be built. The acquisition of the property was enough to convince the Utah Condensed Milk Company that Galt really wanted them.

On January 5, 1917, the *Galt Herald* reported, "The superintendent, bookkeeper, and manager will come from the Utah Plant, while the rest of the employees, totaling forty, will be selected locally. One girl will be necessary in the office; one in the laboratory, and four in the factory." The rest of the employees were men employed to work around the plant receiving the milk from the dairies and shipping the finished product, evaporated milk known as Sego Milk. The salaries ranged from $2 a day to $125 a month. The people pictured here are unidentified.

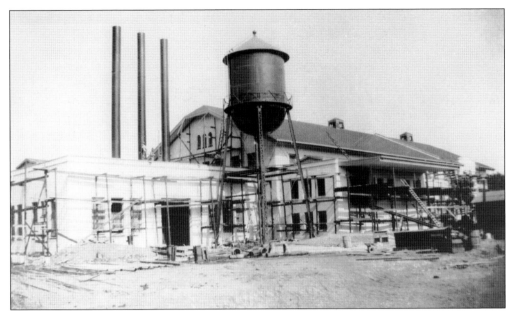

On February 7, 1917, the *Sacramento Union* ran the headline, "Big $200,000 Condensed Milk Plant To Be Formally Thrown Open at Galt on February 7th." Although the milk condenser had been in operation since the previous May, it was not formally opened until then. The article that followed outlined the celebration that was planned.

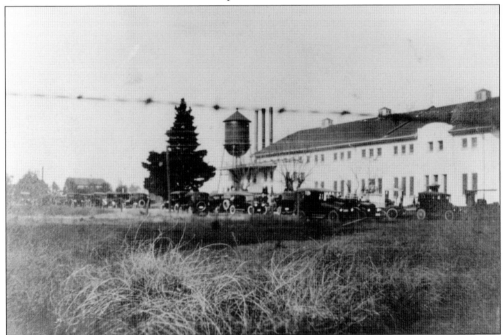

Milk began coming in from the dairies around Galt on September 19, 1917. Gottardo Barsetti was the first in the area to bring in a load of cans filled with milk. Lafe Ward was second, and Tully Kreeger came third. Gus Gerling, Lloyd and Clarence Hauschildt, Carl and Freddie Johnson, Ben Menicucci, Ernie Gudel, James Lavagnino, Pete Masdonati, John Fry, and Fred Harvey were all local dairymen who shipped their milk to the plant.

Robert Carpenter was one of the 43 employees who started work on the first day of operation and is the only employee to work at the plant for the entire lifetime of Sego. He went to work two days before the first deliveries of milk were processed, worked just about every position, and eventually became plant engineer. (Cleo McAllister.)

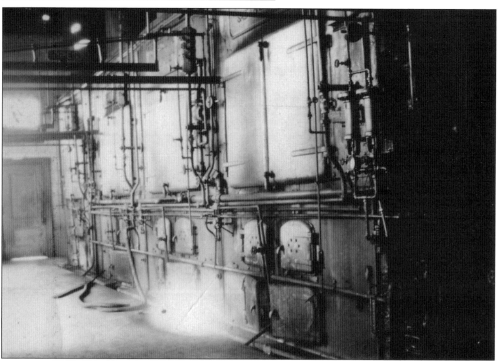

This is the boiler that produced the power and heat to run the plant. In the process of making evaporated milk, raw milk is preserved by heating it to 240 degrees until the butterfat reaches 7.8 percent, about double regular milk, and is then sealed in cans. In the early days, iceboxes were small, so storing milk in cans on a pantry shelf was welcomed. (Cleo McAllister.)

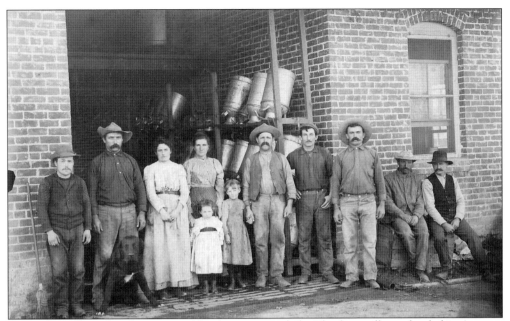

To get the milk to the plant required hauling it twice daily. The first milk was hauled in Autocar trucks. By October 1917, the second of these trucks was purchased. The first milk hauler was Harry Ambrose. Other early haulers were Frank Carpenter, Ben Beossow, and Louis Patterson. The first field man for the Sego Milk Company was George Smith. These employees are posing next to the milk loading dock. (Cleo McAllister.)

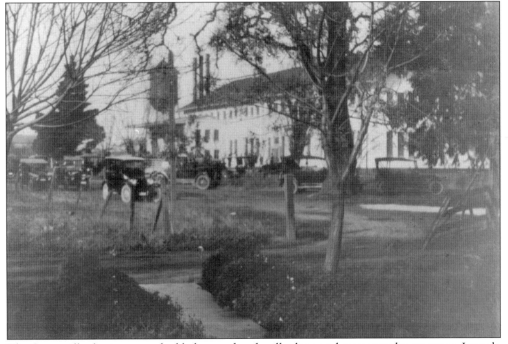

The Sego milk plant grew and added a powdered milk plant and more warehouse space. It made both powdered milk and ice-cream powder, which were especially important during the war years when shipping a perishable like milk to the armed services was next to impossible.

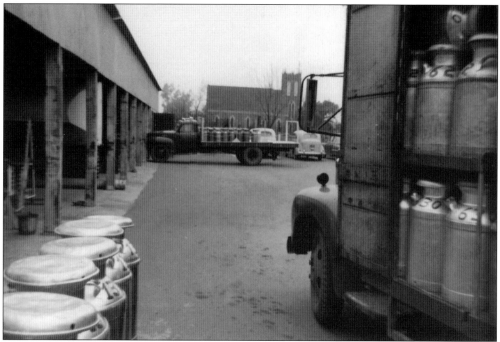

By 1957, the milk haulers were self-employed men whose job it was to haul the milk to the Sego plant twice daily. Each morning, they would go to the dairies, load the milk cans on their trucks, haul them to the plant, and unload them, then drive to the bottom of the ramp and load clean, empty milk cans back on their trucks. (Cleo McAllister.)

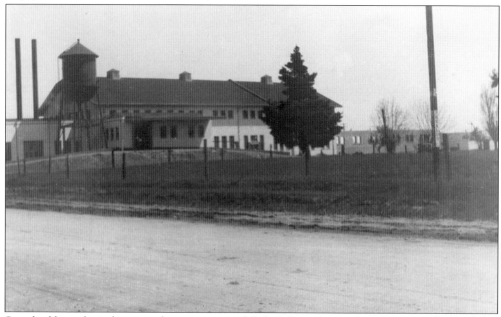

Sego had brought industry to the quiet town of Galt. It brought employment not only for adults, but during the summer, it also helped young people who needed to raise money for their college education. Its whistle, which could be heard throughout the area, started each workday, called time out for lunch, and closed each day at 5:00 p.m.

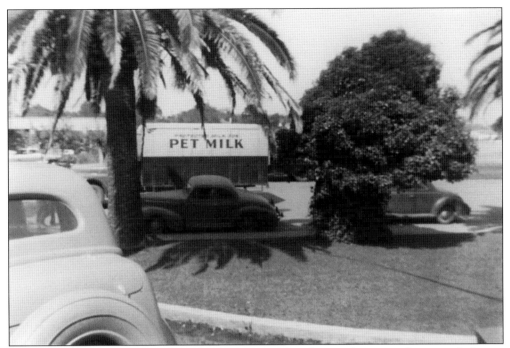

The strenuous task of lifting milk-filled cans into the plant and into trucks twice daily was accomplished by such men as John Mehlhaff, Irving Mehlhaff, Gus Mehlhaff, John F. Mehlhaff, Adolph Mehlhaff, Jack Weber, Chester Caldwell, Joseph Klaner, Don Uhrich, Rasmus Rasmussen, Melvin Welkler, and Jeff Brown. The trucks used were similar to the one pictured here in the background. (Cleo McAllister.)

Sego Milk Company eventually outgrew the Galt plant. With no further expansion possible, Sego closed the plant and sold the building. Over the years, the old building had a number of owners. All of the equipment had been sold until there was nothing left, and the building fell into neglect. The once beautiful grounds became dry and weed-ridden.

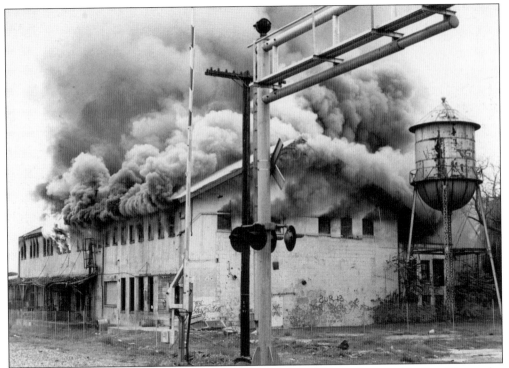

On the afternoon of November 24, 1992, the old Sego building was destroyed by fire. Those who remembered its glory days stood by and watched as the major portion of the plant was consumed. The next day, Thanksgiving Day, the remaining standing walls were crushed under the attack of a wrecking ball.

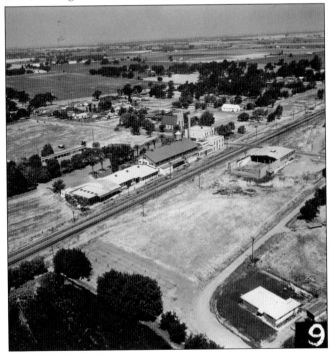

This bird's-eye view shows the plant (center, next to tracks) in its heyday. The Southern Pacific Railroad tracks run through the middle of the photograph from lower left to upper right, while F Street bisects them near the plant. St. Christopher's Catholic Church is at center behind the plant. The large expanse of farmland at the top is the Harvey Ranch. Fred Harvey did not have far to go to bring his milk in for processing.

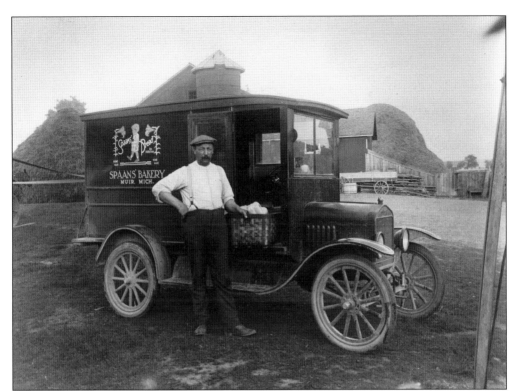

In 1896, Peter Spaans became an apprentice baker in Holland. He came to America with his wife in 1912 and settled in Kansas. He tried wheat farming but soon returned to his trade as a baker after he learned American measurements and pastry preferences. He opened his first bakery in Muir, Michigan. By 1922, he was running a bakery route, selling bread for 7¢ a loaf. Three of his five children became bakers. (Jim Spaans.)

After learning the bakery trade from his father, first-born William Spaans married Anna Start and opened a bakery in 1935, the Spaans Dutch Bakery in Muskegon, Michigan. The shop featured donuts and pastries and even made potato chips for a time. The couple was a team, with Bill baking goods and Anna waiting on customers at the counter. (Jim Spaans.)

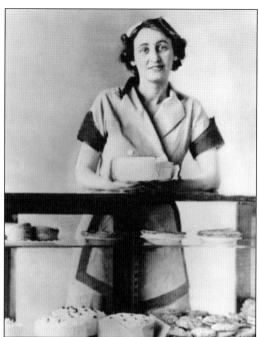

William Spaans and his family moved to sunny California, where they opened and ran a bakery in Modesto from 1948 to 1958. They wanted to live in a smaller town, so they moved again 30 miles south of Sacramento to Galt in 1958. All six of Bill and Anna's children were raised working in the bakery after school and on Saturdays. Their jobs included washing pans, sweeping floors, packaging cookies and rolls, and waiting on customers. Pictured here is Anna Spaans. (Jim Spaans.)

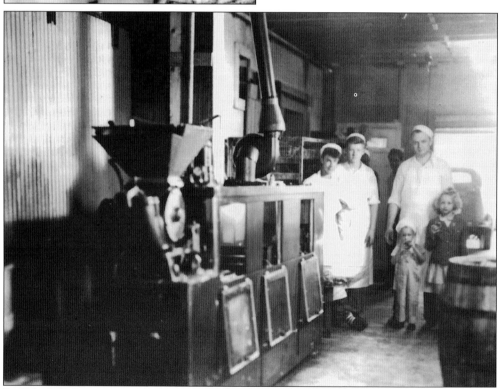

In Galt, Bill Spaans wanted a large production bakery business with quality products and good values. He advertised "Drive A Little, Save A Lot," and packaged products sold five for $1. New equipment helped produce a larger volume of cookies, and the business established distribution to grocery stores and bakeries throughout Northern California. (Jim Spaans.)

Beginning in large ovens and baking on cookie sheets like moms at home, the factory now has large state-of-the-art assembly line machines. The cookies are mixed in one-ton batches four or five times a day. Besides cookies, assorted pastries and holiday pies and rolls are available for purchase. (Jim Spaans.)

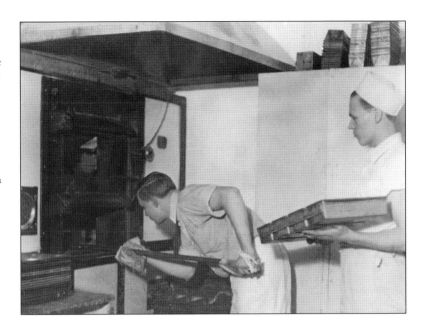

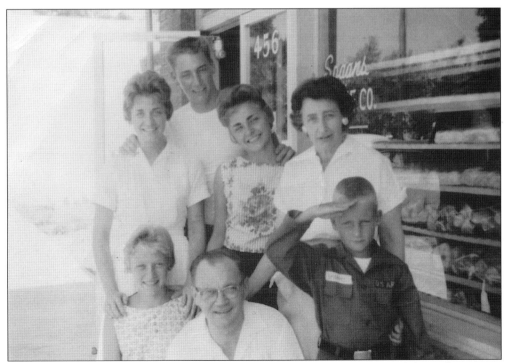

All six of Bill and Anna's children were raised working in the bakery. They did not always want to work, but at an early age, the kids were instilled with a responsibility to the family business and a strong work ethic. Their parents also emphasized education and to be satisfied with what they had and share it with others. (Sharon Spaans.)

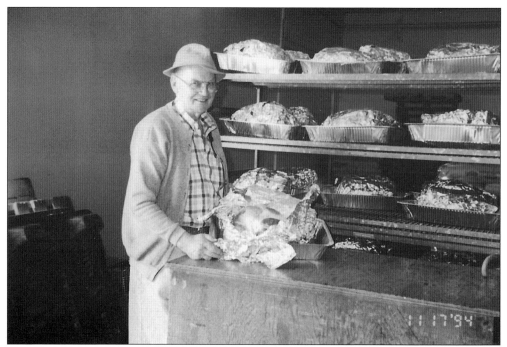

Bill Spaans is shown baking holiday turkeys in the factory ovens for charity. Bill was one of Galt's biggest boosters. He said, "Galt is not a pretty town, but the people are. In the 19 years that I've been here, the town has gone from 1,200 to 4,400 people. I've seen it grow, and I've grown with it." (Sharon Spaans.)

Pictured on the right in a publicity still for a Galt Chamber of Commerce function, Bill Spaans was always willing to lend a hand because he loved the neighbors. He said, "You don't know absolutely everyone, but where else could I walk and wave hello to 20 friends in the seven blocks between work and home?" (Sharon Spaans.)

Five

PARADES, PARTIES, AND OTHER PASTIMES

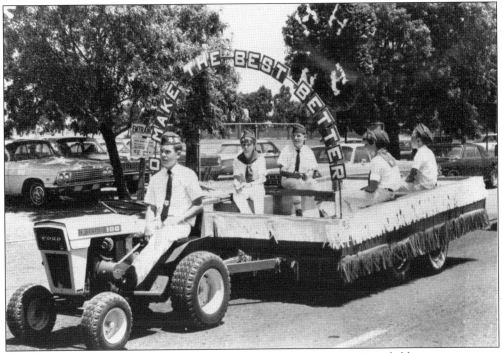

In the early days of a small town, options for leisure time were scarce. As a child, it was even more so. Families found their way to the local watering hole for swimming when there were no chores to do. A game of baseball in the nearest vacant lot was an option. As a town grew, bowling allies and movie theaters became available. When more people moved into town, there were parades on the Fourth of July or picnics down by the river. Organizations like the Oddfellows and Native Sons brought citizens together for celebrations. Young and old needed something to do outside of work.

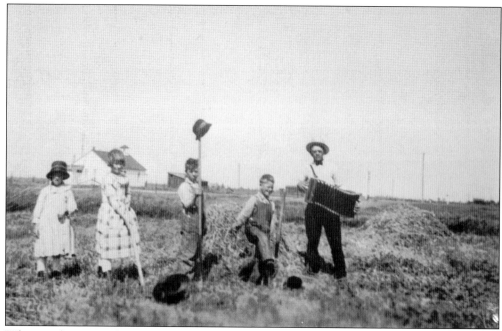

When working on a farm around the Galt area, one takes advantage of leisure time when they can get it. Pictured here around the 1930s is a family taking a break from piling wheat chafe in the field behind one of the Galt area's one-room schools. Dad is playing the accordion while the kids dance.

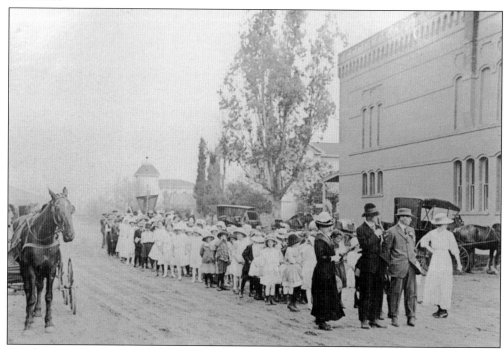

Parades were popular in Galt. This one had the schoolchildren marching from the old school on B Street to the new one on E Street after its opening in 1916. They are pictured here waiting at the intersection of B and Front Streets next to the Brewster Building.

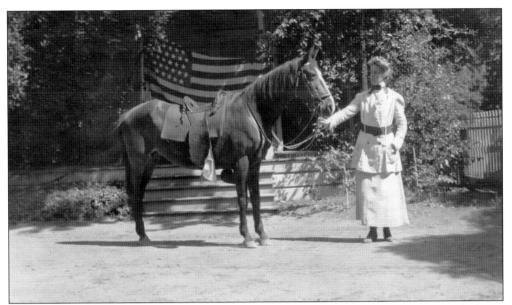

Genevieve Harvey is posing in front of her father's medical office with her horse before a Fourth of July parade. Harvey was quite a celebrity around Galt. Besides being the founder's daughter and an accomplished harpist in the San Francisco Symphony, she was a socialite and an accomplished rider.

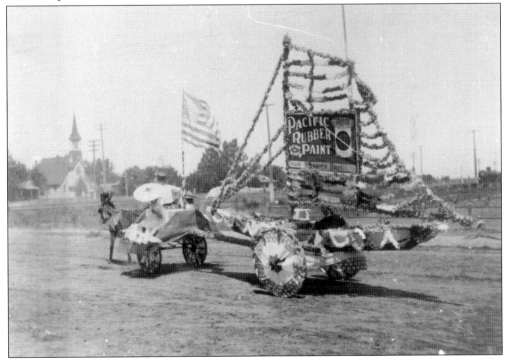

The Sawyer Brothers float is leaving the Fourth of July parade going west on C Street. The stockyards are in the background on the right, and St. Luke's Episcopal Church is in the background on the left. The Sawyer Brothers were advertising their line of Pacific Rubber paint that was manufactured in San Francisco and contained India rubber.

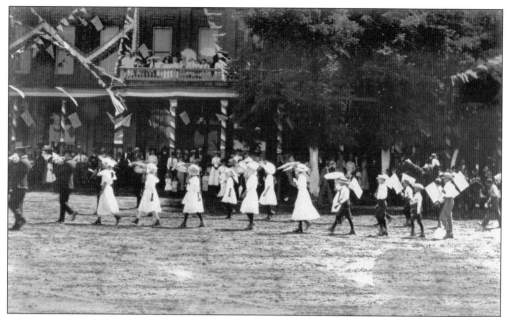

Another Fourth of July parade with a group of schoolchildren is seen passing in front of the Galt Hotel on Front Street while the local band marches in front of them. The hotel is decked out in its finest red, white, and blue decorations. Galt has a history of parade participation, including the Fourth of July, St. Patrick's Day, and the Galt Festival.

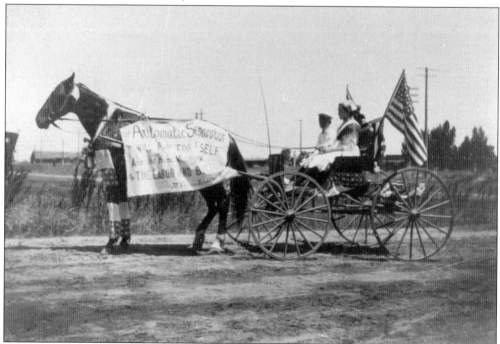

One of the local Galt merchants sent two ladies in a horse and buggy to participate in a Fourth of July Parade in the early 1900s. One of the inventions of the time was a cream separator. It skimmed cream off the top of raw milk without producing any waste, which saved money in the process. The site of this photograph is undetermined.

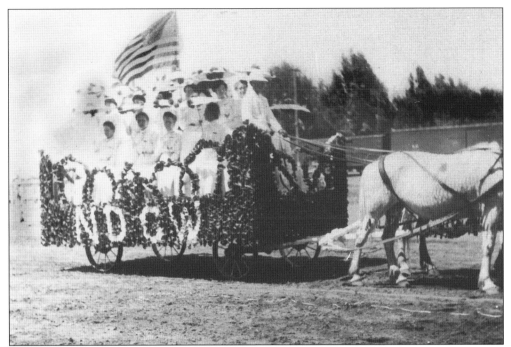

This parade float was put together by the Native Daughters of the Golden West, a nonprofit service organization dedicated to the preservation of California history. The founding of the Native Daughters occurred in Jackson, California, in September 1886. Their brother organization is the Native Sons of the Golden West.

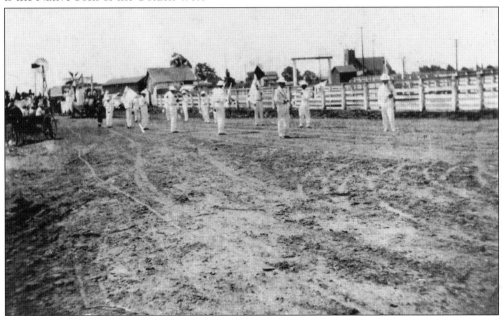

This group of flag bearers and color guards leads a parade north on Front Street with a float trailing behind. On the right are the stockyards near the railroad station. In the background is St. Christopher's Catholic Church. A wagon full of spectators is on the left. It is hard to tell what the celebration is.

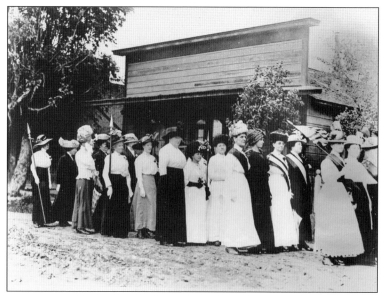

Another group of the Native Daughters of the Golden West wait their turn in line during a Fourth of July parade in the 1890s. In the front row, second from left, is Maude Ferguson. At one time, the local chapter of the Native Daughters used the second floor of the Brewster Building to conduct meetings.

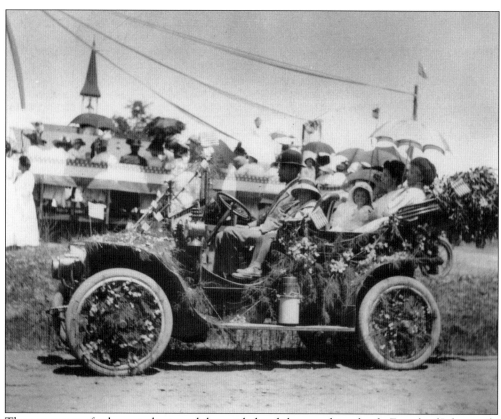

The occupants of a decorated automobile wait behind the grandstands of a Fourth of July parade around the 1910s. It is hard to tell, but the car looks to be a 1910 Stanley Steamer. The owner must have been a wealthy Galtonian. The steeple in the background belongs to St. Luke's Episcopal Church, as the grandstand is facing Front Street.

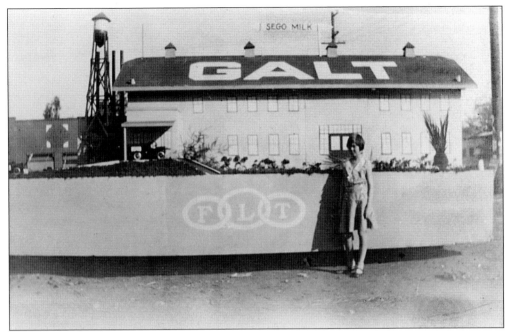

A young girl stands in front of a float constructed by the Independent Order of Oddfellows to honor the Sego Milk Company. In 1957, the Sego plant celebrated its 40th anniversary in Galt, and many of its employees were members of the Oddfellows. The "FLT" on the float represents their motto: Friendship, Love, and Truth.

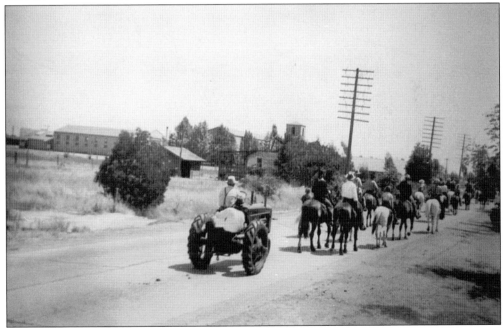

These participants (and/or spectators) of an upcoming parade travel south on Lincoln Way toward C Street, which is where most parades are now held. In a farming community like Galt, tractors were used to pull floats. In the background is Galt High School, and this group just passed what would become Wendy Hope Drive.

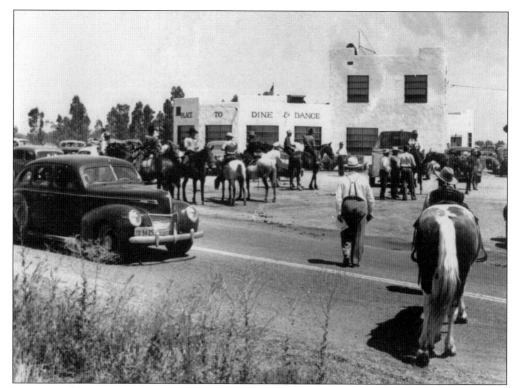

Horsemen from around the Galt area meet at Dowdell's Restaurant in the early 1950s just before a parade. By this time, businesses had moved out to Lincoln Way (old Lincoln Highway) and east C Street, and so did the parades. The route changed from Front Street to C Street, going from west to east. Equestrian units have always been an integral part of parades.

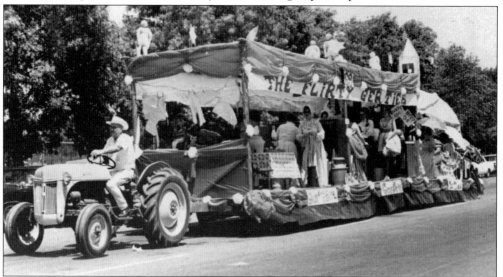

In 1969, the City of Galt celebrated its centennial year as a community. The calendar of events spanned most of the year and included a historical display, a citywide tree-planting program, a Flag Day street dance, the Galt Festival, and of course, a parade. This float belongs to the Flirty Gerties, the women's auxiliary to the Dirty Thirty Club.

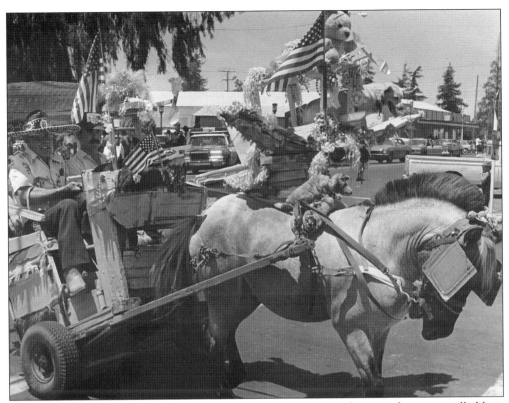

In the 1960s and 1970s, no parade would be complete without a homemade wagon pulled by a pony and driven by John Souza. He lived in the rural area south of Galt. Nobody really knew him or where he came from. He was recognizable not only at the centennial parade, but also just traveling up and down rural roads around town. (The *Galt Herald*.)

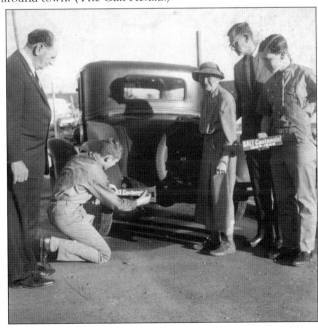

Boy Scout David Wold places a centennial bumper sticker on the car of Mary Pritchard. Other participants are, from left to right, Judge Fred "Buster" May, Mary Pritchard, City Councilman Bob Lawrence, and Scout Bill Fry. Mary's car appeared in the centennial parade, as did many other classic automobiles.

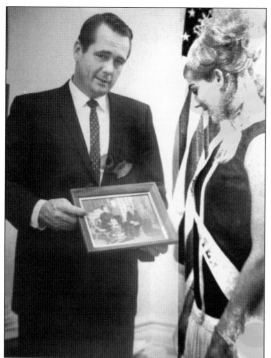

Lt. Gov. Ed Reineke poses with Galt centennial queen Carol Stanley in a publicity photograph. Reineke appeared in place of Gov. Ronald Reagan, who had a previous engagement. Reineke served in the US House of Representatives before he became lieutenant governor of California. (The *Galt Herald*.)

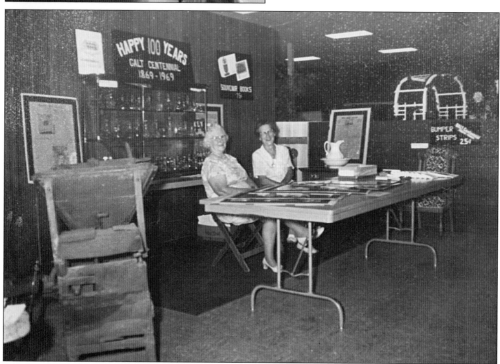

Jan Farrell and Mary Albergetti mind the souvenir table, selling centennial memorabilia at the old county fair administration building on Chabolla Avenue. Items for sale included a souvenir book, bumper stickers, vintage photographs of old Galt, and souvenir pins. The souvenir book contained a history of Galt, old Galt photographs, and ads placed by local businesses.

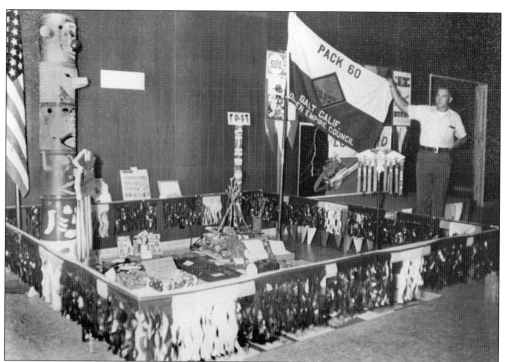

The Cub Scouts of Pack 60 had a display at the centennial celebration in the old county fair administration building. Local groups including the scouts set up displays showing the achievements and histories of each organization. The displays were only set up for a short period of time, as the celebration lasted most of the year, and the building was used for other events.

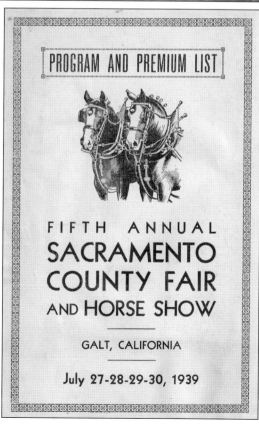

PROGRAM AND PREMIUM LIST

FIFTH ANNUAL
SACRAMENTO
COUNTY FAIR
AND HORSE SHOW

GALT, CALIFORNIA

July 27-28-29-30, 1939

In the mid-1930s, Galt began holding a stock show and fair sponsored by the 52nd Agricultural District that eventually morphed into the Sacramento County Fair. The area is where the Chabolla Center, Flea Market, swimming pool, and Fairsite Elementary School are now. The remnants of an entry arch can still be seen. Fairsite School took its name in honor of the fair that once was.

Galt rodeo queen Arlene May is pictured with Galt mayor Bennie Casado in 1951. Rodeos were one of the main attractions of the fair that was established in 1937. In 1948, the Agricultural District Fair was changed to the County Fair and lasted until 1954, when it was relocated to Sacramento. Galt still has a fair every year.

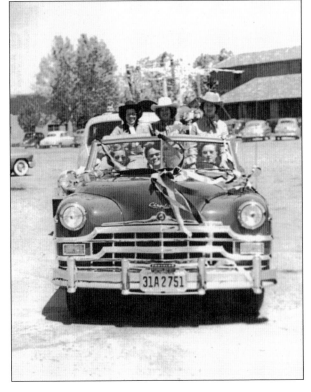

Rodeo queen Arlene May and her attendants are ready to leave the parking lot of Galt High School on their way to the Galt Festival parade in their 1951 Chrysler Windsor convertible. The rodeo queens ended with the final Sacramento County Fair in 1954. Galt Festival queens continued the tradition for a number of years.

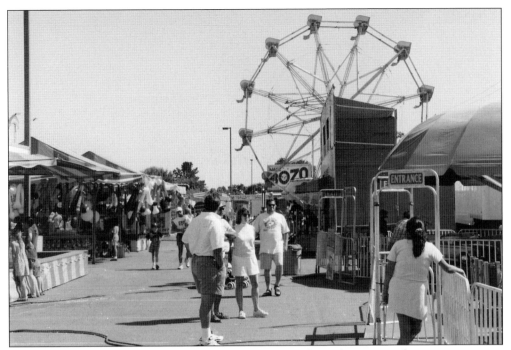

The midway at the Galt Festival, as in most fairs and festivals, is where carnival games, amusement rides, entertainment, and fast-food booths are grouped. The site for Galt's midway has been moved numerous times. In the 1960s, it was at the southern end of Fairsite School. Held during the summer, school would be out, of course. (The *Galt Herald*.)

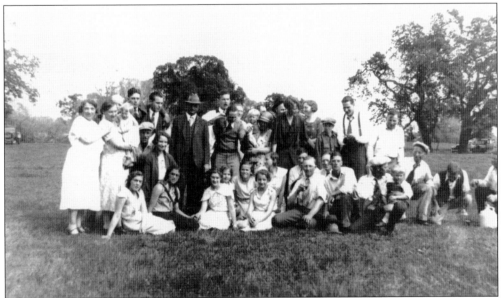

A group of 1920s Galtonians are having a Sunday afternoon picnic in an area residents have nicknamed White Bridges. This favorite recreation spot was located on Twin Cities Road northwest of Galt at a spot where two bridges cross the two forks of the Cosumnes River. The wooden bridges had always been painted white, hence the name. The bridges have since been replaced by concrete and steel.

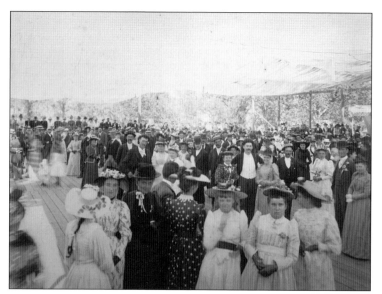

Families are dressed in their finest clothes celebrating the Fourth of July at a Native Sons of the Golden West picnic. The Native Sons, like their sister organization the Native Daughters, is a California nonprofit service organization founded to preserve California's historical heritage. The Galt Natives Sons were Parlor 243. (Cleo McAllister.)

The local chapter of the Veterans of Foreign Wars Auxiliary are posing on their charter night possibly around 1946 or 1947. Members of the auxiliary are relatives of those who served in combat overseas and their charter night celebrates the beginning of their club.

One of the bands that played the Spanish Ballroom (later called the Estrellita Ballroom) was Stewart Hamblen and His Gang. The ballroom was rebuilt from the remains of a fire that destroyed the Spanish Hotel. Big names like the Dorseys and Benny Goodman played one night stands from 9:00 p.m. to 3:00 a.m. with a break at midnight.

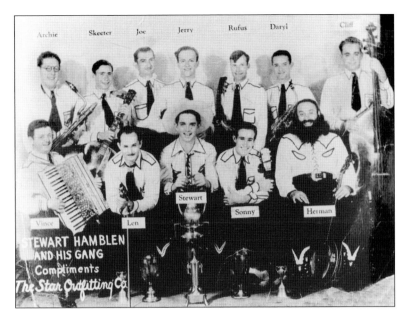

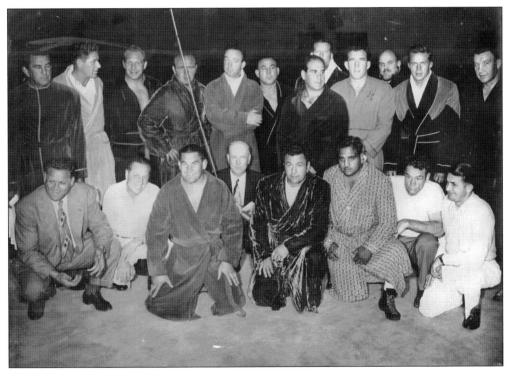

According to longtime Galtonian and former professional boxer Stan Tudorvitch, boxing exhibitions were held in the Estrellita Ballroom in the 1930s. It was said that one-time Galt resident and former heavyweight champion Max Baer boxed in exhibition bouts and helped amateur fighters with their technique. The Estrellita Ballroom would house a continuation high school 30 years later. (Sharon Spaans.)

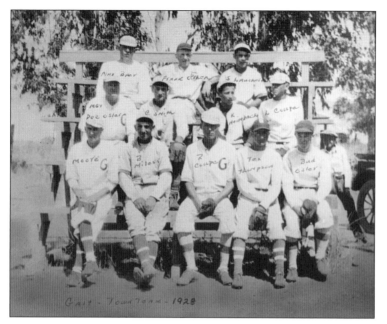

The national pastime has always been a Galt institution going back to its early days. Youth leagues, high school, and town teams plied their craft on sandlots and city diamonds during the spring and the dog days of summer. Former heavyweight boxing champion Max Baer enjoyed his youth in Galt so much that he came back to town and played baseball on the Galt town team. He is seated at top left.

The city of Galt has had youth baseball for decades. Neighboring towns that did not have enough participants to field their own league would enter teams into Galt's league. Local merchants would sponsor teams to pay for uniforms and equipment. The baseball supporters in the second row are, from left to right, Eddie Ambrogio, Louis Listini, unidentified, Ed Hall, and Bill Petty.

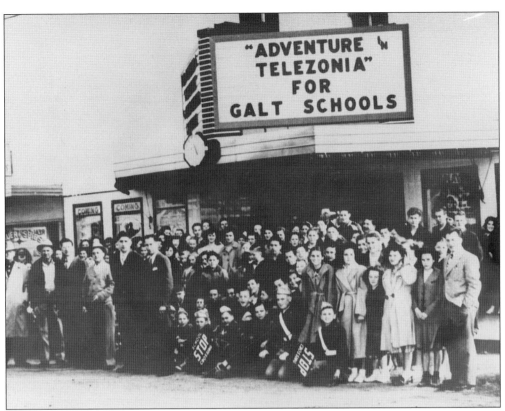

Costing $75,000 in 1949, the Galt Theatre on Lincoln Way was the second theater in Galt (the first being the silent movie theater now occupied by the Valley Oaks Grange Hall). The theater was built by Albert Schauer and Eric Speiss and seated 500. The movie listed on the marquee was an instructional film on the safe use of telephones for kids.

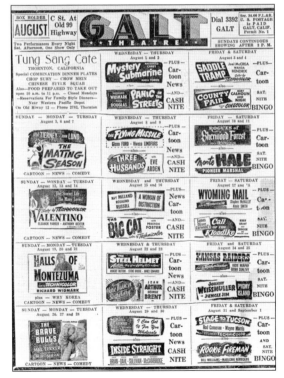

This mail advertisement from the Galt Theatre shows upcoming movies in the early 1950s. The Tung Sang Café helped pay for the mailing by placing an ad with a menu. In addition to a double feature, there were games and a cartoon. Most of the movies in the ad were B movies, with the possible exception of *The Halls of Montezuma* with Richard Widmark. (Cleo McAllister.)

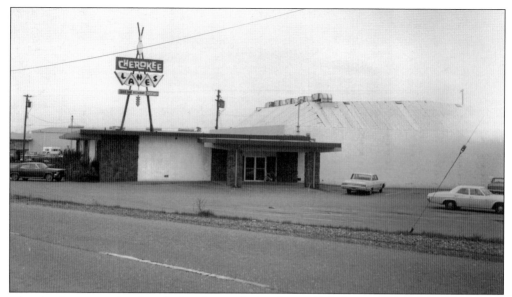

Cherokee Lanes was the place the locals went for bowling in Galt. Located on Fairway Drive south of C Street and next to State Highway 99, Cherokee Lanes was the site of an exhibition game between local bowler Ken Johnson and two-time PBA champion Basil "Buzz" Fazio. The game was won by Fazio on a strike in the 10th frame. Johnson thought he was "playing possum."

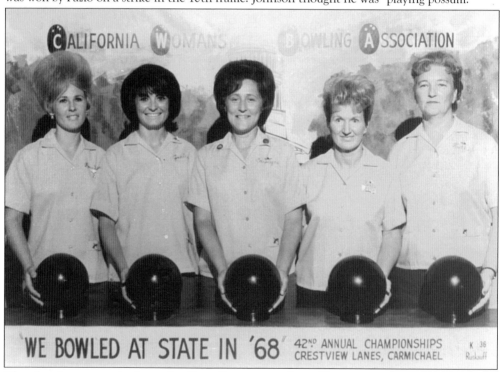

Cherokee Lanes was the home bowling alley to a number of leagues over the years and had a few individuals and teams go to California state tournaments. This team from 1968 traveled to Crestview lanes in Carmichael, California, to compete in the state championships. The ladies are, from left to right, Romilda Rausser, Janice Oberle, Carol Liebig, unidentified, and Ruth Rosa.

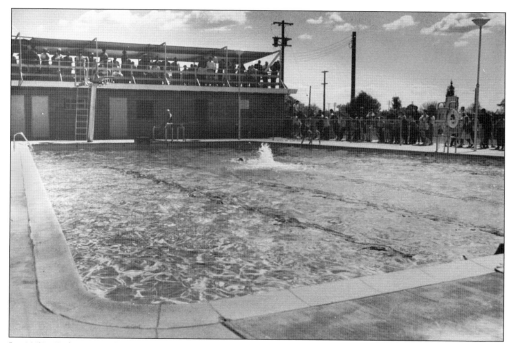

In 1959, Galt opened its first public swimming pool. The drive for the pool began when two local youths, Sterling Dokter and Joe Gill, drowned while swimming in an old gravel pit near Ione. Mayor Bennie Casado was the emcee at the dedication, which attracted over 700 people. He stated the community had long needed a public swimming pool and that "supervised swimming practically eliminates tragedy through the swimming and water safety instruction program to be offered by Galt's Recreation Department."

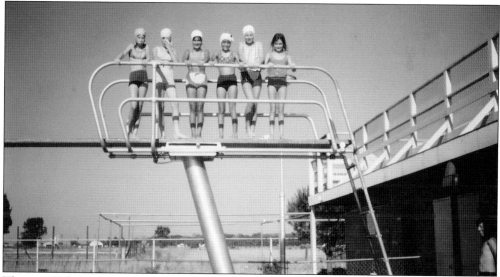

The new Galt Swimming Pool had two pools: one shallow pool for smaller kids and a larger pool equipped with a three-meter diving board. The pool was located southeast of Fairsite School and south of the current aquatic center on Chabolla Avenue and Lincoln Way. The girls on the diving board are, from left to right, Yvonne Prince, Sierra Prince, Kathy Lanza, Luana Listini, Cindy Fay, and Karen Case. (Kathy Lanza Whirlow.)

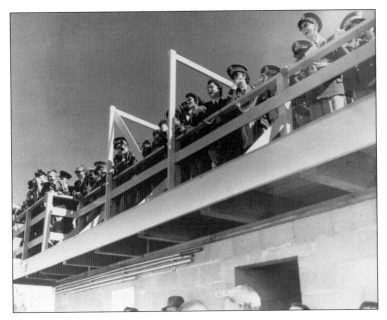

The Galt High School marching band is perched on the second-floor deck of the Galt pool building after their performance for the pool dedication. They seem to be amused at something down in the pool area, possibly the trampoline demonstration that was part of the entertainment. There was also a color guard and food and drink.

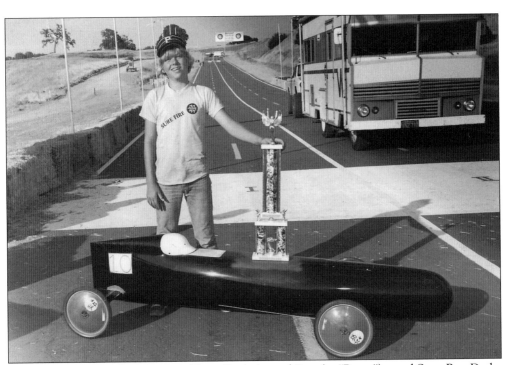

In the 1970s, the Jacobson cousins Chris, Rachele, and Ron (or "Rusty") raced Soap Box Derby cars on a track at Aerojet, a missile-propulsion systems manufacturer south of Folsom. Pictured is Chris Jacobson, who placed in a race at the site. Chris's cousin Rachelle continued on to the finals in Akron, Ohio. (The Galt Herald.)

Six

"I Remember That Place"

All towns go through growing pains in the name of progress. Some businesses change with the times and survive, while others do not. Growing up in any town, citizens have their favorite places to eat, make purchases, or be entertained. Some of these places are lost to eternity and are only remembered in a photograph or a newspaper clipping. Others still exist in another form with only the basic shell to remind us of simpler times. Growing up in Galt, one remembers those places of days gone by with a smile and a daydream, or see a picture and say, "I remember that place."

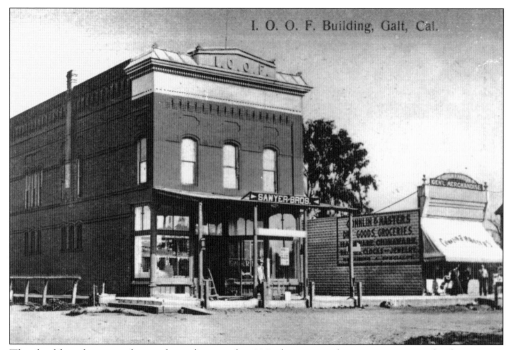

This building has not changed much over the 140-plus years of its existence—only the owners have. Most of those years, it was owned by the Oddfellows until 1996, when the building was purchased by Sacramento architect Bob McCabe. The space is now occupied by Brewster's Bar and Grill. The name is a tribute to the original owner.

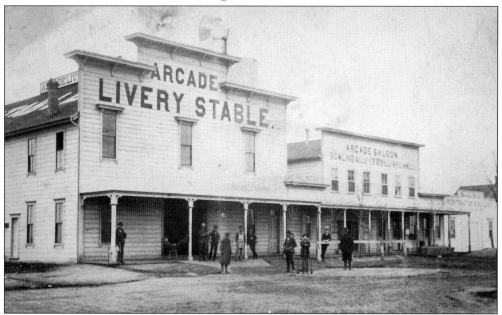

The Arcade Livery Stable was once located on the corner of C and Fourth Streets and was probably consumed by one of many fires that plagued downtown Galt over the years. Builders and city fathers got wise and started building brick and mortar establishments. The Galt Hotel became a new business at this same site years later. (Judy Jacobson.)

George May Draying Company is pictured around 1900. A dray is a low, heavy cart, sometimes without sides, used for hauling. Located at the northwest corner of B and Fifth Streets, May Draying used a two-horse dray to pick up and deliver freight to local merchants. May also dealt in wood, coal, and ice and had a cash-and-carry icehouse south of C Street on Fifth Street.

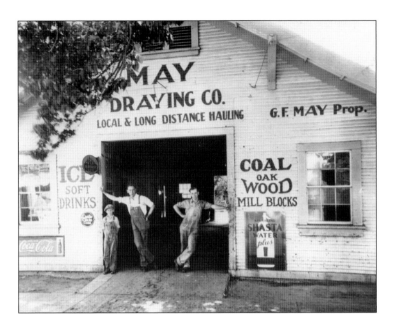

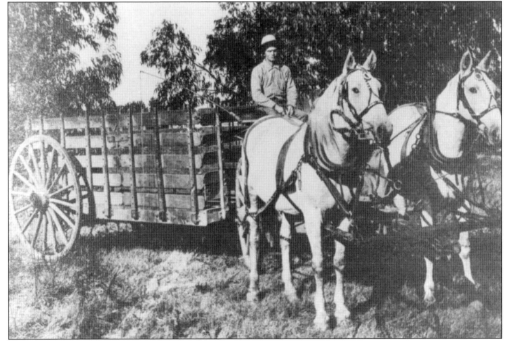

A horse and dray owned by George May Draying Company is pictured making a delivery. People who did not own a wagon or buckboard paid a man like George May to haul supplies. Because the sides of a dray were low, heavy loads like machinery could be hauled from the train station to a place of business.

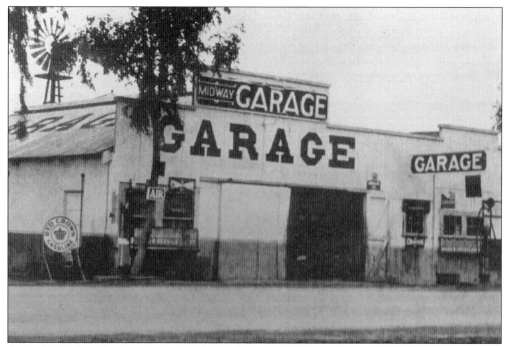

According to local historian Louise Loll Dowdell, the Midway Garage stood close to the northwest corner of C Street and Lincoln Way. One of the eucalyptus trees at left is still there. Dowdell said that when business was slow at the garage, the mechanics would sit outside in chairs, waiting for customers.

This unidentified gas station probably made its home along the Lincoln Highway (now Lincoln Way) during the 1930s. When Henry Ford started to mass produce his automobiles, car ownership was easier than ever. In the beginning, gasoline was purchased at hardware and general stores. The first filling station appeared in 1905.

It is interesting enough to see "Grandma" Caroline Brewster and Rollo Brewster's son Jack in the photograph, but the building behind them is the only known image of the first movie theater in Galt. At the time, movies were silent, and this one had its own piano player. The theater was located on Fifth Street between C and D Streets.

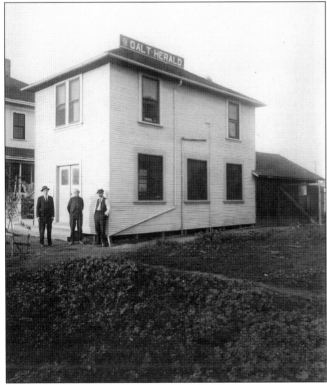

The *Galt Herald* printed its first edition in 1901 and has been in continuous circulation ever since. It replaced the *Galt Gazette* and the *Weekly Witness* as the town's only paper, and all used hand-set type. It was not until the 1930s that the *Herald* upgraded to the linotype printing method. (Judy Jacobson.)

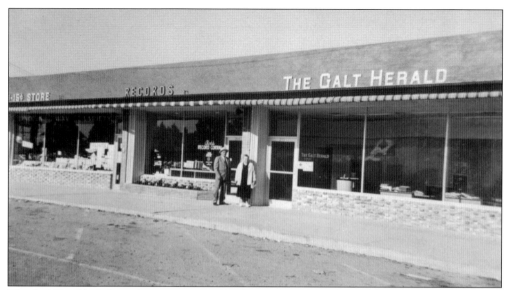

The *Galt Herald*'s C Street location was next to the Galt Theatre. It was at this site that Roy Herburger purchased the *Herald* from then-publisher Hank Tweith in 1959. The paper at that time was still printed on a hand-fed press one sheet at a time. It upgraded to a used duplex press in 1961.

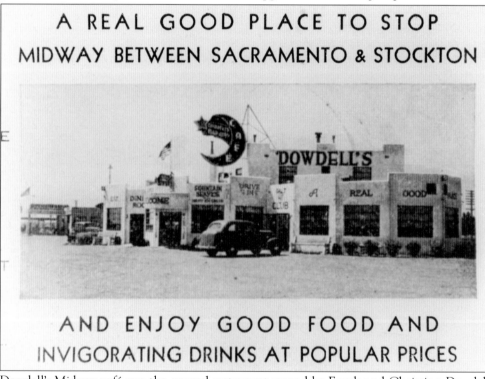

Dowdell's Midway café was the second restaurant owned by Frank and Christina Dowdell, with the first one being on Lincoln Way (the old Lincoln Highway). The new one was built on Simmerhorn Road to take advantage of the new configuration of then US Highway 99 in 1938 (before it went to four lanes in the 1950s). Louise Loll Dowdell said they had a large banquet hall and bar, making it a popular place between Stockton and Sacramento.

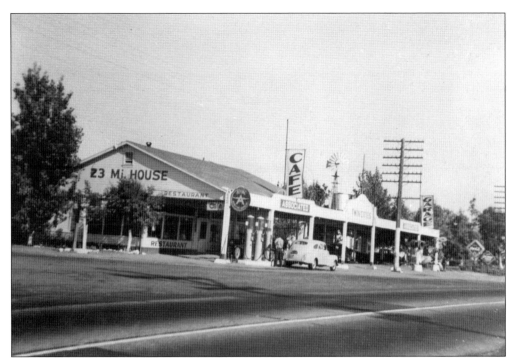

The 23 Mile House was located in the vicinity of Twin Cities Road and the Lincoln Highway/US Highway 99. It was so named because of the distance from that site to Sacramento. The 23 Mile House had a full-service gas station, café, and an automobile service garage. Nothing remains of the building.

Ed Hall owned Galt Motors, a Chevrolet dealership located on Lincoln Way in the 1950s. Seen here leaning against a Need Ranch truck with his chief mechanic Archie Skaggs, Hall serviced all makes and models of cars and trucks and would even wash vehicles. Galt Motors was located across from the Galt Theatre.

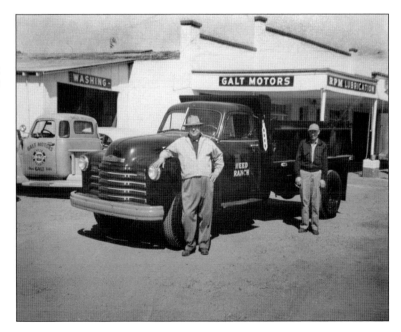

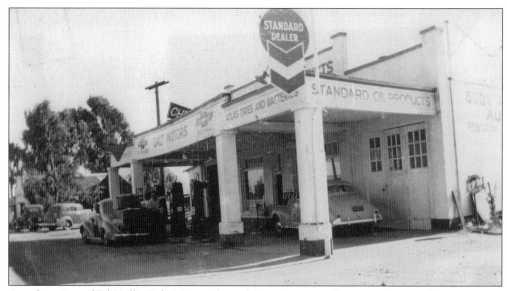

Another view of Ed Hall's Galt Motors shows his station attendant pumping gas for a customer. Judging by the photograph, Hall did not keep many new vehicles on his lot. Some dealers only had a few models on display; customers had to order the model they wanted, and then wait for the car or truck to be delivered. (Cleo McAllister.)

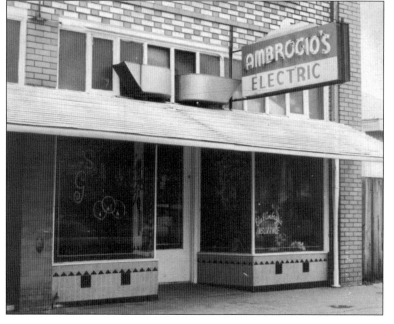

Eddie Ambrogio opened Ambrogio's Electric on Lincoln Way in 1930. He had one Philco and one Sparton radio console. He moved his business to 229 Fourth Street in 1933 and was there until his retirement. Eddie and his mother had a dairy in Galt between 1920 and 1930; he was once the only milk delivery boy in town.

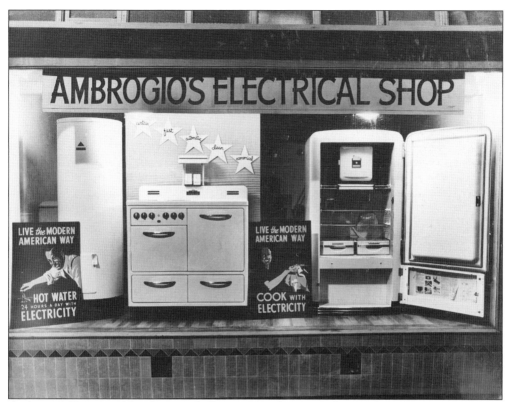

Ambrogio's Electric sold and serviced all types of appliances such as washers, dryers, dishwashers, small appliances, refrigerators, stereos, and televisions. This window display shows major kitchen appliances for sale in the store. His Fourth Street store was housed in one of the oldest buildings in town, rebuilt after a fire in 1932.

Ray Arlin's Galt Pharmacy was located at 217 Fourth Street in the old part of Galt, close to Ambrogio's Electric. Arlin's store had a full-service pharmacy and soda fountain, plus it stocked nonprescription drugs and sundries. Competition from newer pharmacies and fast-food drive-ins spelled doom for the Galt Pharmacy.

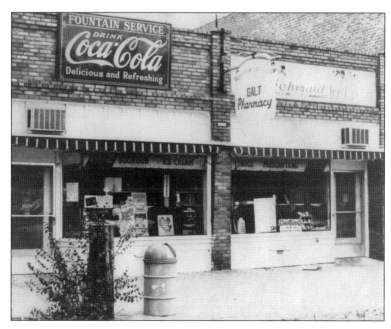

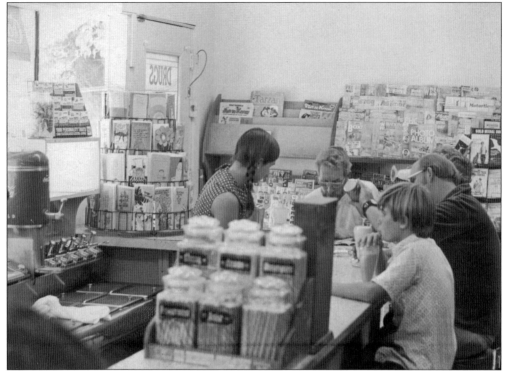

The interior of Ray Arlin's Galt Pharmacy shows Julie Arlin working behind the counter of the soda fountain. Arlin's ice cream of choice was Richmaid Ice Cream made in Lodi, California. In their heyday, you could find soda fountains in pharmacies, dime stores, department stores, and ice-cream parlors. They served milkshakes, sundaes, and soda made fresh from carbon dioxide and flavored syrup.

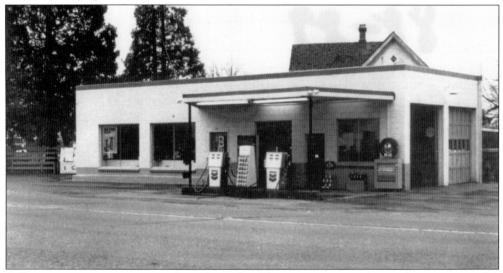

Full service gas stations are rare these days. This Chevron station on the northwest corner of A Street and Lincoln Way provided an on-duty mechanic, a gas pump attendant, and tire shop. There was no convenience store. The only food and drink available on the premises were from vending machines, like the one seen here.

In 1916, Farmers & Merchants Bank opened its doors in Lodi. Around 1938, bank president E.J. Mettler noticed the closing of the Bank of Galt and wanted to replace it with a Farmers & Merchants Bank. The Galt branch had its grand opening in the old Galt Bank building on July 1, 1948. The move to the 811 C Street location happened in the late 1950s. Notice there is no shopping center yet.

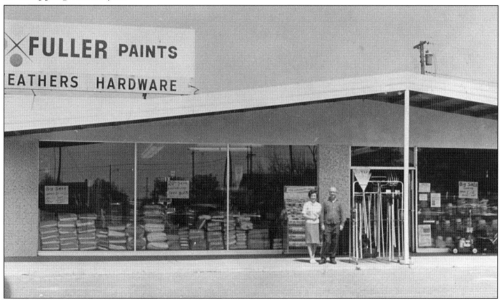

Weathers Hardware was a fixture in the Galt business community for 52 years. Bill and Marjorie Weathers started their hardware business in the traditional Fourth Street business district. Around 1960, they moved to bigger quarters in the Galt Shopping Center on C Street. Upon retirement, Bill and Marjorie turned the Weathers Hardware business over to their son Noel.

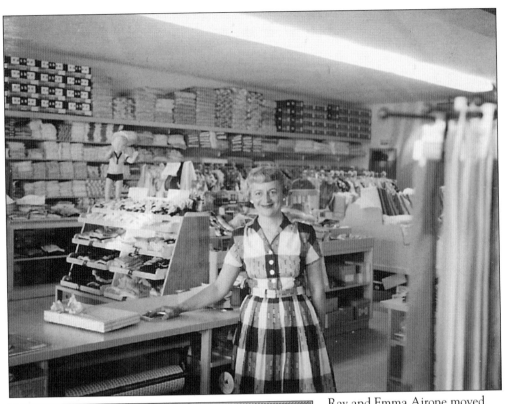

Ray and Emma Airone moved to Galt in 1956 and opened the Galt Department Store on the corner of Fourth and C Streets. In 1961, they moved the store to the other end of C Street in the new shopping center. It was the only store in town to stock children's clothing. The Airones retired in 1977. (Ray Airone.)

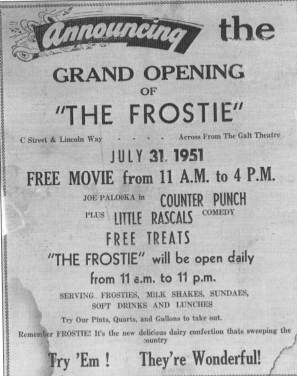

Announcing the

GRAND OPENING
OF
"THE FROSTIE"

C Street & Lincoln Way - - - - Across From The Galt Theatre

JULY 31, 1951
FREE MOVIE from 11 A.M. to 4 P.M.

JOE PALOOKA in **COUNTER PUNCH**

PLUS **LITTLE RASCALS** COMEDY

FREE TREATS
"THE FROSTIE" will be open daily
from 11 a.m. to 11 p.m.

SERVING FROSTIES, MILK SHAKES, SUNDAES, SOFT DRINKS AND LUNCHES

Try Our Pints, Quarts, and Gallons to take out.

Remember FROSTIE! It's the new delicious dairy confection thats sweeping the country

Try 'Em ! They're Wonderful!

This handbill advertises the grand opening of Galt's newest drive-in, the Frostie. Opening in 1951, it was the brainchild of Galt entrepreneurs Albert Schauer and Eric Speiss. These two businessmen are also responsible for the construction of the Galt Theatre. The ad suggests that the theater was in cooperation with the Frostie and its grand opening. (Cleo McAllister.)

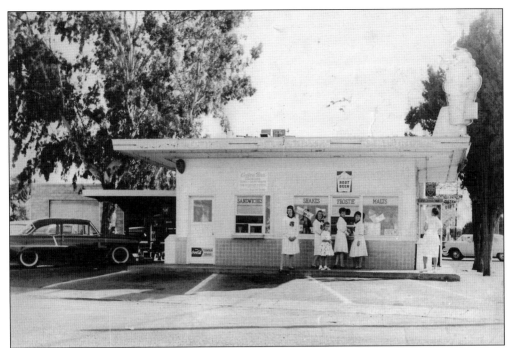

Bert and Marguerite Baker purchased the property at 800 C Street, which included the Galt Frostie, in 1956. Marguerite called her niece Martha and Marion "Hatch" Hatchell and asked if they would be interested in moving to California, buying the Frostie business, and running it. They were living in Raytown, Missouri, at the time. The Hatchels packed up the house and headed to California. The grand opening was October 31, 1956. (Dody Hatchell Wasser.)

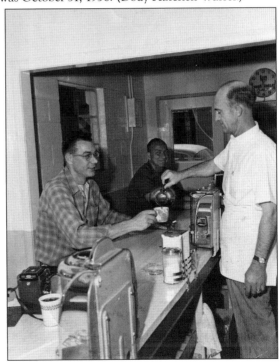

Hatch enlarged and added a counter to serve lunches, and the Frostie became the coffee shop for people like Art Heinle of Farmers & Merchants Bank, Ray Airone of the Galt Department Store, Bill Doan of Mar-Val Foods, Eric Spiess, Ben Salas, Al Fernandez, and Herman Lavine. Hatch's "coffee klatchers" would always try to "out flip" him for a cup of coffee. Hatch sometimes ran the whole show himself, as he liked to cook and talk at the same time. It was a great place to pick up the news of Galt. (Dody Hatchell Wasser.)

Louie DeMartini opened the Golden Acorn Restaurant in 1965. Situated next to Dry Creek Golf Course, it was noted for its Italian food. DeMartini learned the restaurant trade from his parents, who owned the Cosmopolitan in Lodi and the Sunnyside Lodge at Lake Tahoe. The Golden Acorn still exists under new management.

The Golden Acorn restaurant was also the scene of a few hot stove league luncheons put on by local television stations and Major League Baseball. Hot stove leagues refer to the time years ago when people would sit around a potbellied stove at the general store during the winter and talk about baseball. One luncheon had former San Francisco Giants pitcher Gaylord Perry and KXTV sportscaster Creighton Sanders talking about the baseball season. (The *Galt Herald*.)

For 27 years, Dr. Vernon E. Greer Jr. was one of Galt's most well-known residents. He was of the generation of doctors who still made house calls. It was said that Dr. Greer delivered a whole generation of Galtonians. He was a member of the Galt Elementary School Board for 17 years. This was Dr. Greer's office on C Street near Fourth Street.

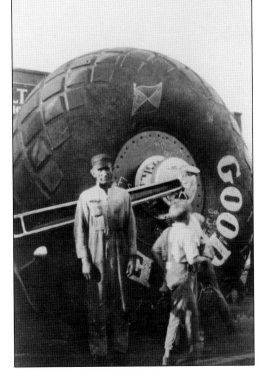

Angus "Red" Quenell was noted as a master mechanic in the city of Galt. He was the person responsible for the maintenance of the school buses belonging to Galt High School and Galt Elementary School, and it was at the back of Quenell's Garage that former heavyweight boxing champion Max Baer trained for a short time. Here Red Quenell stands in front of a tire display at his garage.

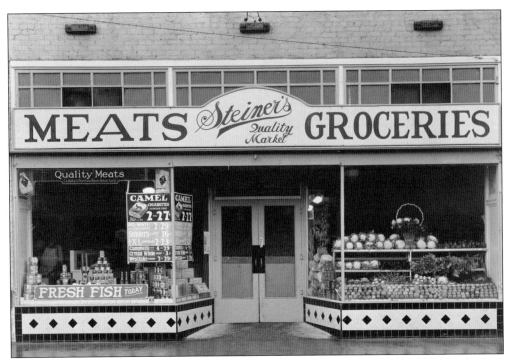

Albert Steiner opened the Galt Meat Market in 1916 with his partner Alfred Zender. Steiner bought out Zender in 1929, and the meat market became Steiner's Market. The store was remodeled in 1931 and reopened in 1932. Another remodel in 1952 added appliances. Albert Steiner also served on the first Galt City Council. (Wanda Steiner.)

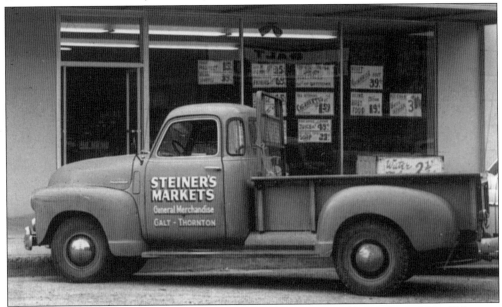

Albert Steiner opened another store in Thornton in 1934 managed by Ferdinand "Ferd" Steiner. In 1954, management of Steiner's markets was turned over to Albert's two sons Bob and Dick, who remodeled the stores for a third time. Albert Steiner passed away in 1960, and the stores closed within a few years. (Wanda Steiner.)

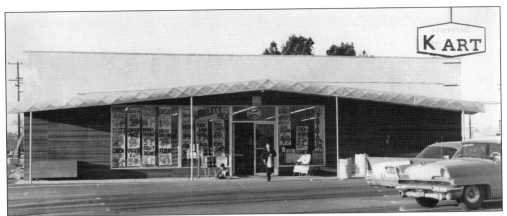

Al Weakley managed a store called the E-Zee Mart when it opened in September 1964 on a triangular piece of property bounded by Lincoln Way and Seventh Street. The following year, the store was sold to Al Weakley, Manuel Cardenas, and Gene Anderson and renamed the Shopping Kart. In the mid-1960s, it was one of three supermarkets in Galt.

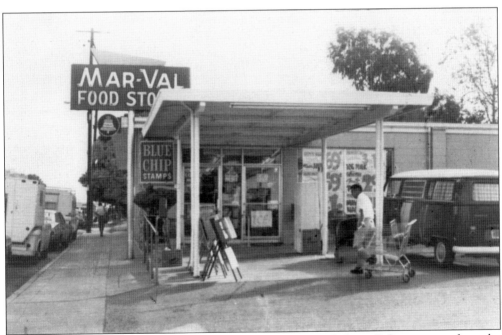

A small chain of grocery stores called Mar-Val had a store in Galt on C Street across from the Galt Shopping Center. It was one of three grocery stores in Galt along with the Shopping Kart and Galt Super Market. Mar-Val was started in 1952 by Mardee and Val Kidd, and Lodi was their first store. The Galt store opened in the 1960s.

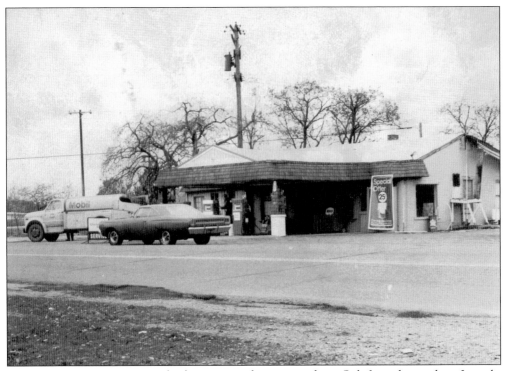

The Curve service station was the first station when approaching Galt from the south on Lincoln Way. Located between Chabolla Avenue and Meladee Lane, the Curve went through many different versions over its lifetime, including this one in the early 1970s. It has since been demolished.

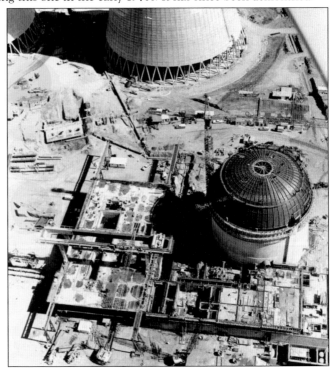

Kids going to school in Galt during the late 1960s and early 1970s saw new faces come and go. The phenomenon was related to their parents helping construct the Rancho Seco Nuclear Generating Station, located east of Galt. It operated from April 1975 to June 1989, but because of a non-nuclear instrumentation system failure, the plant was closed by public vote, having never reached full capacity.

Seven

"Government of the People, by the People, for the People"

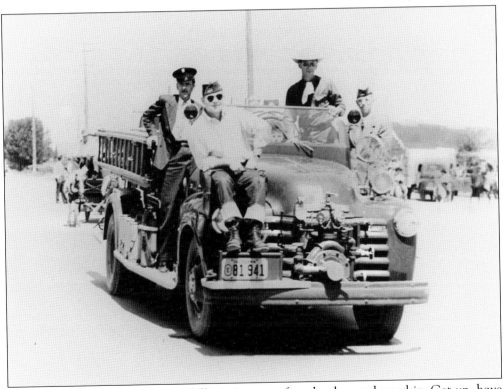

Life in a small town can be an idyllic existence of work, play, and worship. Get up, have breakfast, wave to the neighbor, go shopping, and maybe have a bite to eat at the lunch counter. Everything is peaceful. All appears to run smoothly in town. The daily mechanics of municipal, county, and federal operations keep the citizenry worry free. Where would residents be without government services?

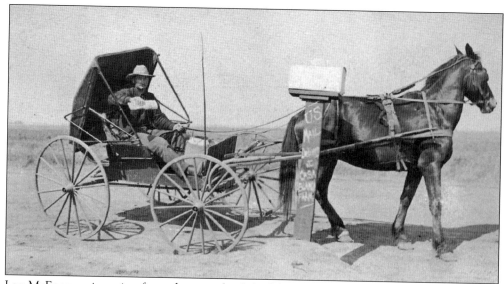

Leo McEnerney is posing for a photograph while delivering mail with his horse and buggy in the rural area east of Galt. Besides owning a store on Fourth Street, McEnerney was a substitute mail carrier for the Galt Post Office. In the early days of Galt, mail was delivered by any mode possible. At the time of this photograph, around 1910, McEnerney was delivering mail to the Casa Blanca Farm.

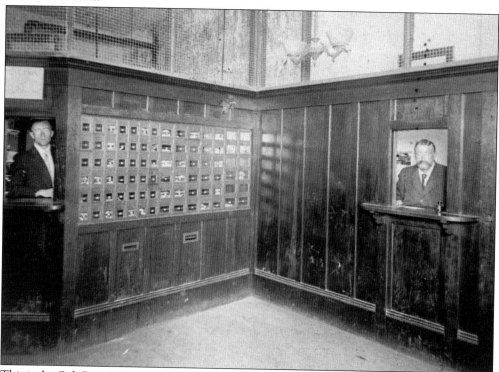

This is the Galt Post Office as it appeared in the 1920s, with clerks waiting for the next customer. With the development of parcel post service by postmaster general Frank H. Hitchcock in 1913, the volume of mail greatly increased. Because rates were now inexpensive, city and rural customers began to order products from distant cities to be delivered by mail.

Galt postmistress Cleo Mollring inspects a new page of postage stamps at the downtown post office. Cleo was a postal worker for parts of four decades from the 1940s to the 1970s. The local post office in Galt moved to different sites throughout its existence, including a "hole in the wall" office on C Street, according to former postal worker Louise Loll Dowdell.

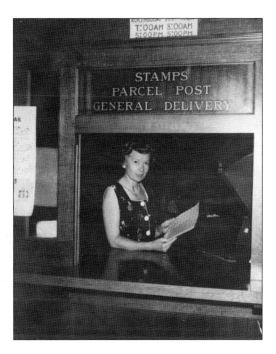

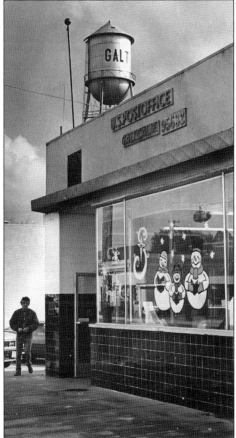

The US Post Office has had two locations on C Street, with the first being the location near Fourth Street, and the second pictured here on the corner of Fifth Street. The newest branch on North Lincoln Way has more space than all the others combined. This space is now occupied by Spaan's Cookie Company.

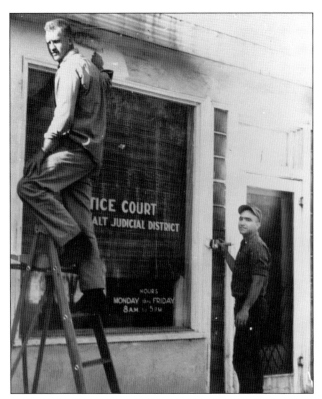

A maintenance crew gives the C Street home of the Elk Grove/Galt Judicial District a fresh coat of paint. Elvin Miller is standing at right. At the time of this photograph, Judge Fred L. "Buster" May presided over all legal matters concerning Galt citizens. Judge James P. Henke followed Judge May and battled to keep a local court in Galt for another 26 years.

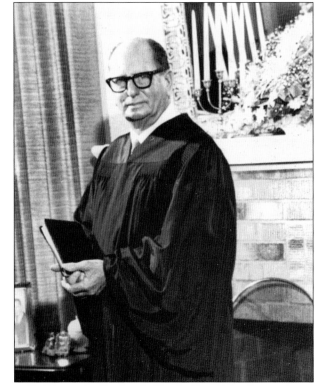

Fred L. "Buster" May was born on May 5, 1909. He served as a deputy in the Sacramento County Sheriff's Department for 22 years, mostly on the Sacramento River Delta. He was elected judge of the Elk Grove/Galt Judicial District in 1964. Judge May was reelected six years later and retired in 1975 as the last "lay" judge (he was not an attorney first before running for judge). (The Galt Herald.)

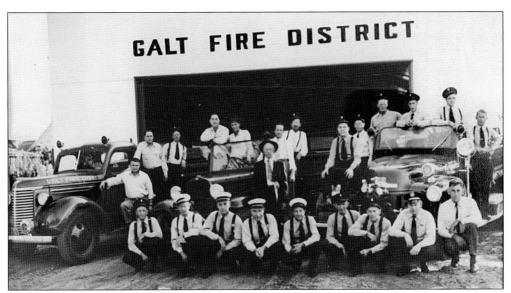

The Galt Fire Department was established on June 13, 1921. For many years, it was an all-volunteer force led by Fire Chief Fred Rothenbush. The Fire Commission Board consisted of F.H. Harvey, F.G. Faweet, and J.L. McEnerney. When it was founded, the department had a budget of about $1,000 and was limited in equipment.

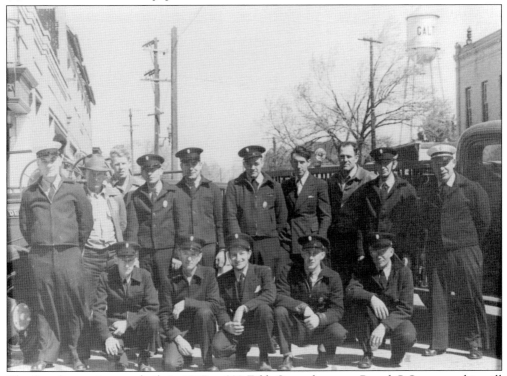

The first fire station was built in 1947 at 229 Fifth Street between B and C Streets and is still being used today. A second station is located at 1050 Walnut Avenue in the northeast section of town. The first paid fire personnel were hired in 1961 and consisted of a fire chief and an assistant fire chief.

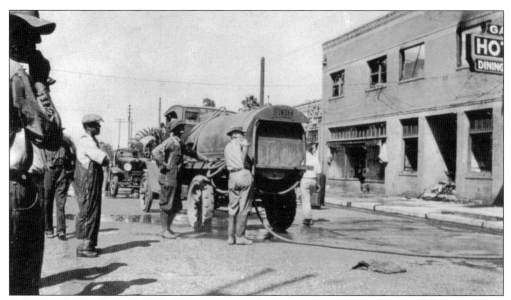

Galt's first firetruck was a REO chassis with a soda acid–type engine and was built by volunteers. The total cost of the truck project was $1,259. At the time, the Galt Fire Department did not have a station, so all fire equipment was stored at Quenell's Garage. Red Quenell was a member of the fire department and the apparatus operator.

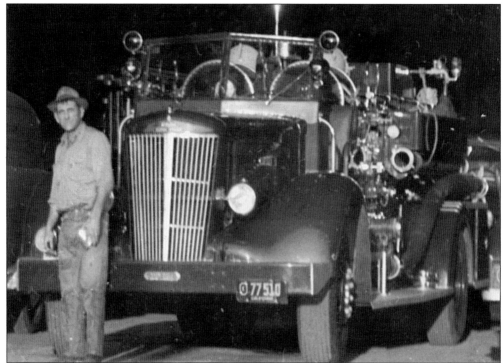

Galt volunteer fireman Dominic Menicucci stands in front of what looks like a 1952 Mack firetruck. Menicucci was a dependable and hardworking fireman who could be counted on at the most critical moments. He manned fire apparatus during the late 1940s and early 1950s. Menicucci passed away in 1985.

An unidentified woman is wading through knee-deep water near the 23 Mile House Restaurant. The Cosumnes River breached a levee during the Christmas season of 1955, sending water for miles east of the river. The Cosumnes River is one of the few almost entirely unimpeded rivers in California. Local fire and police departments, including those of Galt, helped with the emergency.

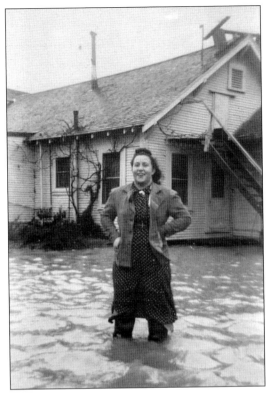

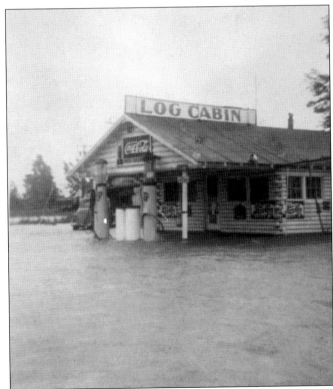

Another building is inundated by floodwaters from the Cosumnes River in the flood of 1955. The jet stream from Hawaii generated a "Pineapple Express" series of storms that battered California and caused balmy conditions in the mountains. The storms dropped 10 to 13 inches of rain in the mountains and caused the snow level to rise to 9,000 feet. Melting snow caused rivers to swell in the valley.

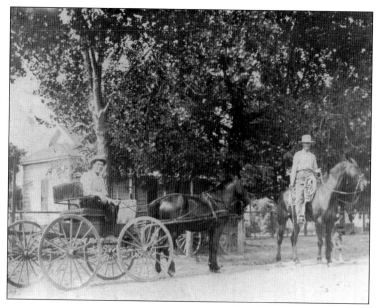

Pictured on horseback is Galt constable Rollo Holiday Brewster at the Pearson Home on Oak Avenue. Brewster was the first constable in Galt's early history. Constables were either elected by popular vote or appointed by the presiding judge of the justice court for cities and towns with populations of less than 40,000. Constables had full police powers by state law.

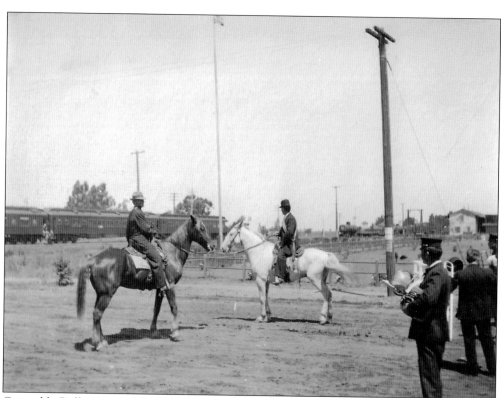

Constable Rollo Brewster is once again on horseback, keeping order during the arrival of an important dignitary arriving by train. Another City of Galt official waits on a white horse with the local city band on standby. The location of this picture is E Street at the Southern Pacific Railroad tracks. The stockyard corrals are in the back right.

Galt constable James Gann poses with his horse at home. Gann was the second constable after Rollo Brewster and did his policing in the 1920s. At the time, constables were the equivalent of a police officer of today. It is undetermined if the constables of the early days of Galt were elected or appointed by a judge.

Members of the Alessandro Marengo family pose for a portrait in the early days of Galt. Tragedy would occur later as a gunman killed the parents and daughter Mary over a horse deal gone bad. With a few others on the killer's list, Constable Gann hunted down the man responsible, a sheep trader named Goins, and delivered swift justice. Pictured is Alex and Matilde with children (from left to right) Mary, Teresa, Joe, Gus, and Tony. (Linda Burge.)

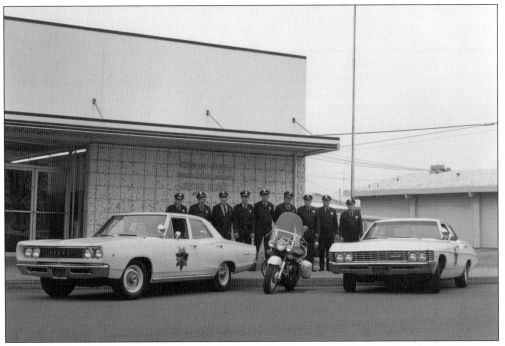

When the City of Galt incorporated in 1946, the police department also came into being. For years, law enforcement used the Lee Township Justice Court Office on Fifth Street across from the fire station. The police department moved into a 150-square-foot office in the city hall building on the corner of C Street and Lincoln Way in 1965. The jail consisted of three steel rings attached to the wall where prisoners were handcuffed.

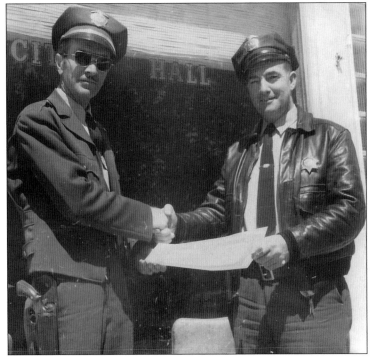

Chief of police Walter E. Froehlich (left) served the department from its inception until he retired in 1978. The first police chiefs like Froehlich also served as patrol staff and hired part-time officers to help enforce the city's laws. Froehlich said he was the city's only paid officer and also the public works director and the building inspector.

Froehlich would patrol for a half hour at a time during the day, then went to work in the Public Works Department doing street and construction work. Police service calls in his early days went directly to Froehlich's house, and his wife, Merrill, would act as dispatcher and send him to the call.

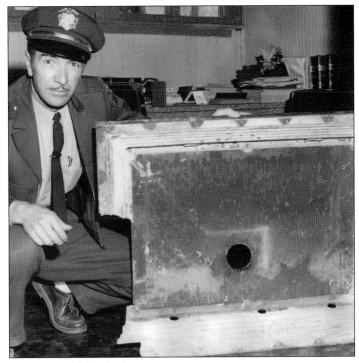

The city council car drives down a city street before one of the many parades of the time. Mayor Bennie Casado sits in the front passenger seat with local businessman Eric Spiess driving. The city council consists of five members who are elected on a nonpartisan basis by the citizens of Galt to a four-year term. The mayor is selected by the city council and serves a two-year term.

Pictured walking through Warrior Stadium is Ida Bellie, Charlie Bellie, and California lieutenant governor Ed Reineke during the City of Galt's centennial celebration in 1969. Bellie was the city's first treasurer, from 1946 until 1968, and one of the original Galt City Council members in 1946. He also worked for Sego Milk Company as a fieldman.

Robert "Bob" Biederman was the mayor of Galt during the centennial celebration in 1969. The 71-year Galt resident served on the Galt City Council for 30 years and was mayor twice. Biederman was a warehouse foreman for General Mills in Lodi from 1948 to 1984. (The *Galt Herald*.)

Eight

FOUNDING FAMILIES AND LOCAL LEGENDS

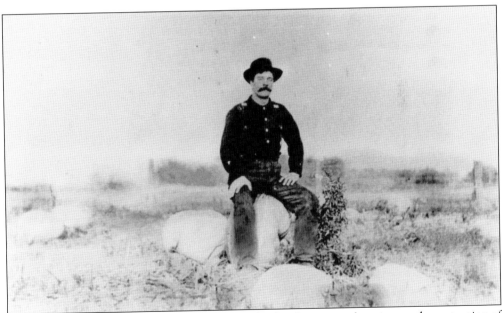

Every city and town has those people noted for the development, education, or the protection of its citizens. Throw in the occasional character, and a list forms of the who's who in a particular community. Since the first day Dr. Obed Harvey helped lay out the town, Galt has seen its share of the famous and not so famous known only to those who have written the 95624 area code on their return address.

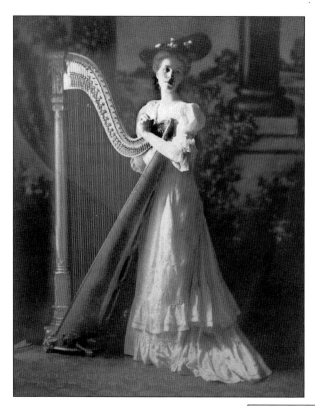

Dr. Obed Harvey had a daughter named Genevieve. She attended the best schools, including a stint in a Boston finishing school. Genevieve learned to play the harp so well that she earned a first chair spot in the San Francisco Symphony. She received a 40-year pin with the Red Cross and taught Sunday school at St. Luke's Episcopal Church. Genevieve never married and lived in the Harvey home her entire life.

Fred Harvey was the son of Galt founder Dr. Obed Harvey. He acquired a piece of the Harvey Ranch for his own dairy. The entrepreneurial spirit in Fred motivated him to contact the Utah Condensed Milk Company and convince them to establish the Sego Milk Company in Galt. He now had another place to send his milk and could build a larger dairy. (Cleo McAllister.)

George Lippi, oldest son of Amadeo and Guidita Lippi, enlisted in the US Army during World War I. Assigned to Company L, 363rd Infantry, Lippi saw active service in the Argonne Offensive in France, where he lost his life. George Lippi became the only Galt casualty during World War I and is buried in the American Cemetery in Montfaucon, France.

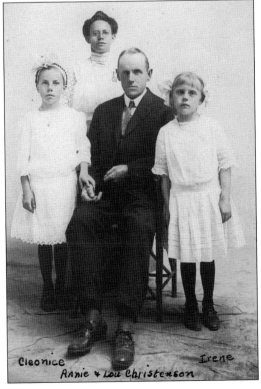

Cleonice Irene
Annie & Lou Christenson

Louis Christensen was another area farmer who married into another Galt farming family, the Fergusons, around 1903. Louis and Annie had two daughters, Cleonice and Irene, and all lived on a farm close to the Ferguson Ranch northwest of Galt. Annie Christensen died in 1912, leaving Louis a widower with two teenage daughters. Christensen Road is named after the family. (Cleo McAllister.)

Frank Joseph Ritz came to California from New York around 1902 as a trained machinist. His first job was working for the Southern Pacific Railroad in its Sacramento shop. He moved to Galt to open his own business, a shop specializing in gas engines, pumps, and well supplies. He married Maude Ferguson and had two daughters, Cleora and Martha. Ritz had one of the first houses on the new Lincoln Highway. (Cleo McAllister.)

Maude Ferguson Ritz was a native Galtonian born in March 1878. She was the daughter of James and Mary Ferguson. James helped built St. Luke's Episcopal Church in Galt. Maude went to Galt schools and worked in the Galt Post Office for 12 years. She was a lifetime member of the Native Daughters of the Golden West and, with the death of her brother Tom, owner of T.S. Ferguson Lumber Yard. (Cleo McAllister.)

New York native Thomas Swift Ferguson was the son of James and Mary Ferguson and brother of Maude Ferguson Ritz. Ferguson was educated in the building trades and was a general contractor. He purchased the Don Ray Company and owned T.S. Ferguson Lumber Yard. Ferguson did a little farming on the side, with a 10-acre vineyard across Dry Creek in San Joaquin County. (Cleo McAllister.)

Mary McFarland was the daughter of John McFarland's brother Duncan and wife of McFarland Ranch hand George Orr. Since John McFarland had no children, Mary was the heiress to the McFarland Ranch, which included 1,600 acres of pasture, vineyard, and dairy. She was also a member of the Rebekahs Lodge of Galt.

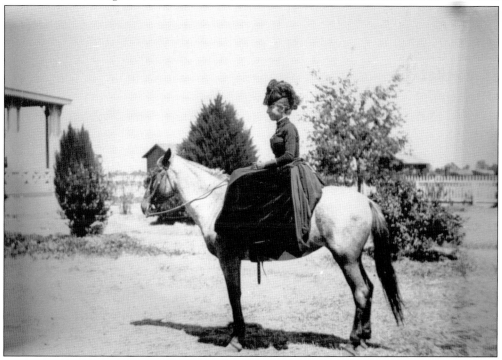

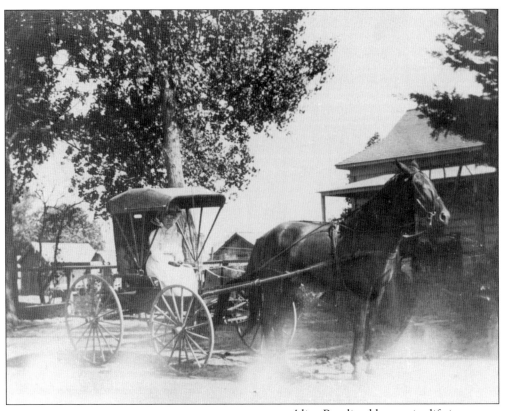

Alice Rae lived her entire life in the Victorian home her father, Galt rancher John Rae, built in 1868. The house still stands on Oak Avenue as a museum. Rae taught school in Galt for 30 years and was the town's city clerk in 1955. This photograph was taken in back of the Rae House as Alice sits in her horse-drawn buggy.

In 1928, principal William Rutherford instituted the Junior College of Aeronautical Engineering at Galt High School. There were hangars for the airplanes that were on loan from March Field. A pilot's license could be obtained by those who were enlisted in the program. Fifty-three men graduated from the program. The concept was unusual, and Galt High School was acclaimed for its special curriculum. Rutherford was a licensed pilot.

After he graduated from Galt High School in 1927, future Galt businessman Eddie Ambrogio enrolled in the Galt Junior College of Aeronautical Engineering. He says it was one of the greatest memories of his life. From this experience, Ambrogio became successful in life. Of the others who graduated from the program, one became the head of Pan American Airways, another became the head winemaker at the Sebastiani Winery, and still another became a four-star general. (Eddie Ambrogio.)

Thomas Quiggle was the son of Volaski and Isabella Quiggle, who built the first Herald store. Thomas attended Alabama School, then went to school at the Atkinson Business College. Once finished, he went to work for Whitaker and Ray for 13 years and Wallace Sawyer for 2 years. He bought out his father's interest in the Herald store in 1913. Thomas Quiggle has the distinction of being the first boy born in Galt. (Linda Fletcher Burge.)

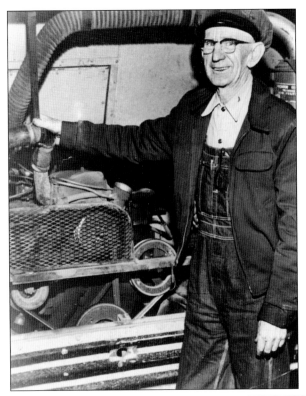

Angus "Red" Quenell had an engine repair shop on the corner of C and Fifth Streets. Besides servicing all of the school buses for Galt High School and Galt Elementary School, Quenell was a volunteer fire engineer for the Galt Fire Department. He was in charge of the upkeep and storage of all the firefighting equipment. Quenell was a veteran of World War I.

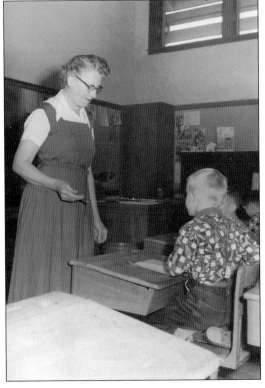

In late summer of 1947, Principal Martin Cabalzar was interviewing a teacher candidate, Marie Olson. As he reviewed her resume, he learned that she had experience teaching kindergarten classes in her native South Dakota. Cabalzar asked if she would be interested in starting a kindergarten program at Galt Elementary School. Olson was, and she developed the program and held that position for the next six years until she retired. She went on to start the Galt Seniors Club and serve as a city librarian.

Beatrice Orr Hayenga Smithson, the grandniece of John McFarland, was born in the McFarland home. After the passing of her parents, she continued to farm the land with her first husband, Charles Hayenga. The passing of Charles caused Beatrice to lease the land until her death, when it was sold to the Nature Conservancy. The conservancy sold 105 acres to Sacramento County, which leases 35 acres to the Galt Area Historical Society.

The "Artistic Eccentric" is what many people called Sally Baxter Sperry. The artist, poet, writer, and playwright lived in the old Liberty Schoolhouse that had been moved to Galt 100 years before. Sperry taught history and English at Galt High School for one year. She printed numerous books in her home on antique presses, self-published on her Laurel Hills Press label.

Born in Nebraska and raised in Colorado, Roy Herburger graduated from the University of Missouri with a bachelor's degree in Journalism. After a stint in the Air Force during the Korean War, he purchased the *Galt Herald* in 1959. Under Herburger's ownership, the *Galt Herald* has moved twice: to A Street across from Galt High School, and the present location on north Lincoln Way. (The *Galt Herald*.)

Pictured are two of Galt's long line of librarians, Edith Hagen and Philip Loring. Hagen arrived in 1964 when Marie Olson was the head librarian at the B Street location. Loring became head librarian when Marie Olson retired and the library moved to its C Street location. The Galt Library is part of the Sacramento Public Library System. (The *Galt Herald*.)

Michiye Shintani Yenokida grew up in Washington State around Poulsbo. After the bombing of Pearl Harbor in 1941, the Shintani family was moved to the Tule Lake Relocation Center. At the end of World War II, Michiye moved to California, where she met her husband, Menoru. While working on the family ranch and raising five kids, Mich went to work for the Galt Elementary School district in 1962 and then Galt High School as the librarian in 1969. She retired in 1996. (The *Galt Herald*.)

Born in Oklahoma but raised in Galt, Judge James Henke presided over the Elk Grove–Galt and Walnut Grove–Isleton Judicial Courts. He received his bachelor's degree from California State University, Sacramento, and a law degree from the University of the Pacific, McGeorge School of Law. Besides being a judge, Henke farmed a 65-acre grape vineyard on his Arno Road property. (The *Galt Herald*.)

Hundreds of Galt school children would know Robert Gordon "Bob" Dunnett as the large, gruff, no-nonsense bus driver who logged hundreds of hours driving kids to and from school. What they did not know was that he served aboard the aircraft carrier USS *Hancock* in the Pacific during World War II. Later, Dunnett would go on to be citizen of the year, Galt city councilman, and mayor. (The *Galt Herald.*)

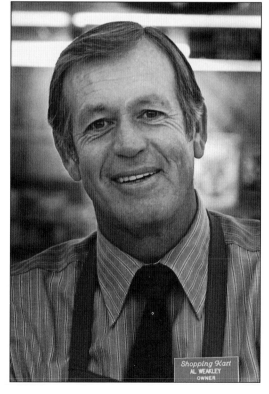

Albert Bristo Weakley was born on September 21, 1935, in Oklahoma. He brought his young family—wife Naomi, son Alan, and daughter Georgia—to Galt to open the E-Zee Mart grocery store in 1964. From there, Weakley took two partners, Gene Anderson and Manuel Cardenas, and opened the first Shopping Kart at 701 D Street in Galt. His motto for the Shopping Kart was "Big enough to serve you, small enough to know you." Weakley was involved in the community, including the Lions Club, Jaycees, and chamber of commerce. (The *Galt Herald.*)

For over 25 years, every March 17, the City of Galt became Irish due to the efforts of a local man named Tom Farrell. Starting in 1955, the honorable Lord Mayor Farrell presided over tugs of war, Kangaroo Court, Irish sweepstakes, and the traditional corned beef and cabbage dinner. In 1970, it was decided to change the name of Galt one day each year to St. Patrick. (The *Galt Herald*.)

Marian Lawrence earned her teaching credential at South Dakota State University and served in the Women's Army Corp during World War II. She moved to Herald in 1948 and began her teaching career before moving to the Galt Elementary School District in 1951. After retirement, Lawrence was elected to the Galt City Council, where she was elected Galt's first woman mayor. (The *Galt Herald*.)

DISCOVER THOUSANDS OF LOCAL HISTORY BOOKS FEATURING MILLIONS OF VINTAGE IMAGES

Arcadia Publishing, the leading local history publisher in the United States, is committed to making history accessible and meaningful through publishing books that celebrate and preserve the heritage of America's people and places.

Find more books like this at
www.arcadiapublishing.com

Search for your hometown history, your old stomping grounds, and even your favorite sports team.

Consistent with our mission to preserve history on a local level, this book was printed in South Carolina on American-made paper and manufactured entirely in the United States. Products carrying the accredited Forest Stewardship Council (FSC) label are printed on 100 percent FSC-certified paper.

MADE IN THE